New Territories

The Computer Visions of Jürgen Ziewe

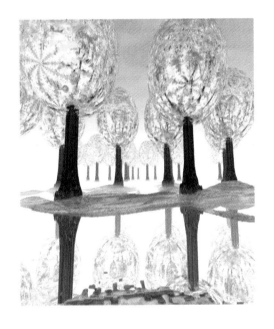

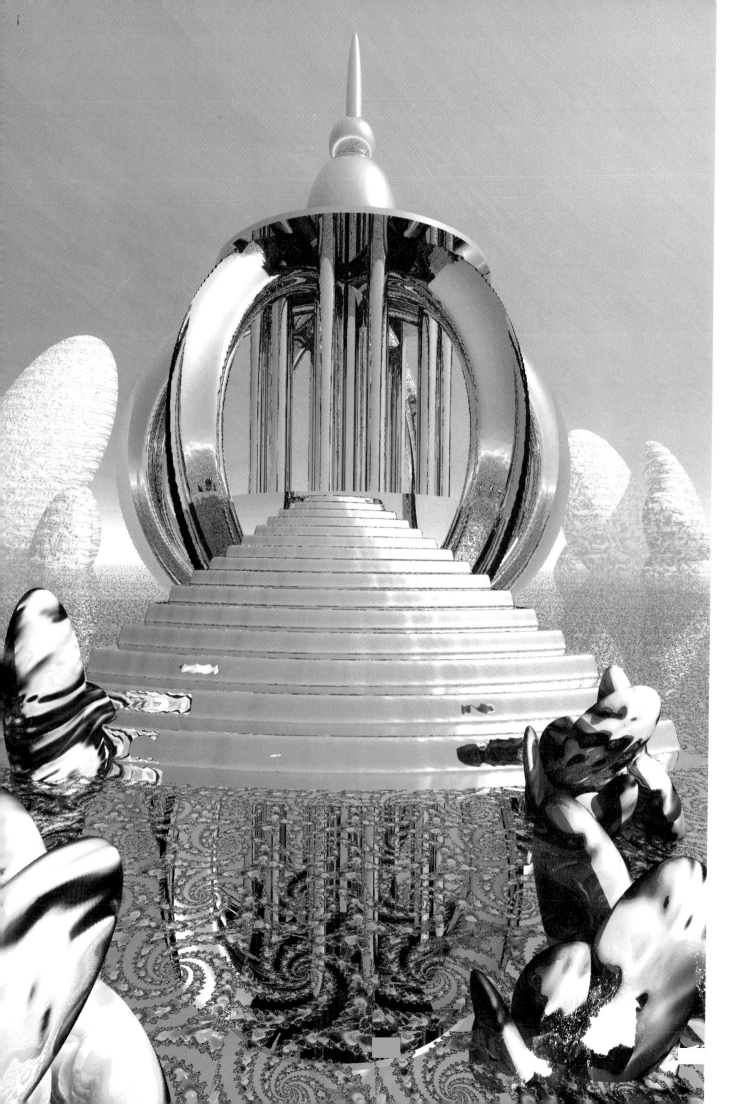

New Territories

The Computer Visions of Jürgen Ziewe

Text by Nigel Suckling

Paper Tiger

Paper Tiger
An Imprint of Collins & Brown Limited

First published in Great Britain in 1997 by
Collins & Brown Limited
London House
Great Eastern Wharf
Parkgate Road
London SW11 4NQ

1 3 5 7 9 8 6 4 2

British Library Cataloguing-in-Publication Data:
A catalogue record for this book is available from
the British Library

ISBN 1 85028 407 5 Limpback

Editor Helen Williams
Designer Nigel Coath at ProCreative
Art Director John Strange
Editorial Director Pippa Rubinstein

Printed in Slovenia

◀ Previous page
Temple of the Night 1996
Sketch

Contents

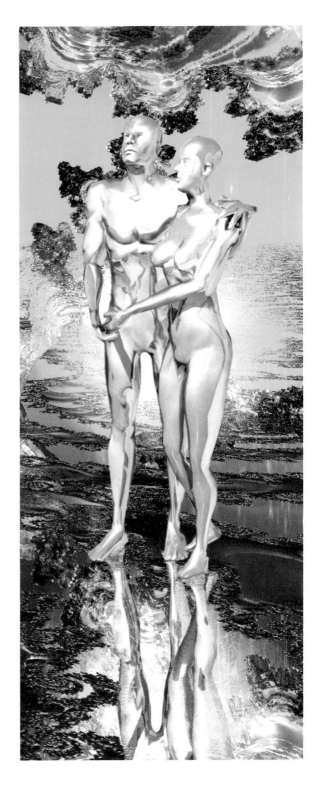

Introduction

When Jürgen Ziewe got married, a clairvoyant friend told him that he had been given 'a certain ability to convey pictures from the cosmos to large numbers of people'.

'At the time this seemed ludicrous as I couldn't even find anyone to pay a fiver for one of my paintings. I just thought – she doesn't know what she's talking about. But now, through computers, my art has reached many thousands of people in just three or four years, so in a modest way it seems she was possibly right.'

Although computers have been the instrument of Ziewe becoming a professional artist, his background is in abstract painting, which he studied at the Hamburg Academy in Germany. However, it is through his creations on the computer that he has become widely known.

Dolphin Dreams 1996 ▶
Poster: Bigger Splash
Programs: KPT Fractal Explorer, KPT Bryce, Strata Studio Pro, Photoshop

The background was generated first and arose from a fascination with turning fractal patterns into 3D landscapes. The luminous colours of the result were so unearthly they suggested the space setting, the sky being reflected in very still water. It is not being suggested, however, that somewhere out in space one might find a scene like this with leaping dolphins – it is a landscape of the mind.

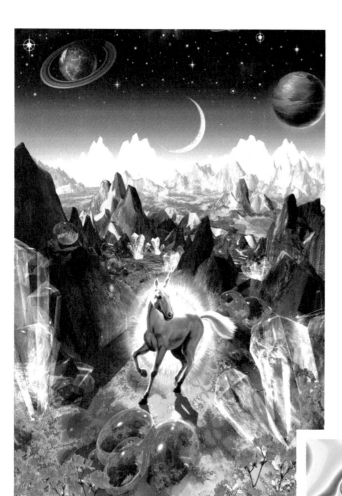

◀ **Fractal Unicorn** 1994
Poster: Cartel/Athena
Programs: MandelZot, Strata Studio Pro, Photoshop

The design was originally commissioned by Athena, who provided the unicorn image. They then sublicensed it to Heron Cards who printed it in a shiny, 3D etched-silver format. The mountainous background is the same as in The Mermaid (page 25) but seen from a different angle.

◀ **Fractal** 1996
Program: KPT Fractal Explorer

The 2D version of the landscape in Dolphin Dreams (opposite). As a monochrome or grayscale pattern it was fed into KPT Bryce, which read it as a contour map for translation into 3D – the lightness of areas deciding their height.

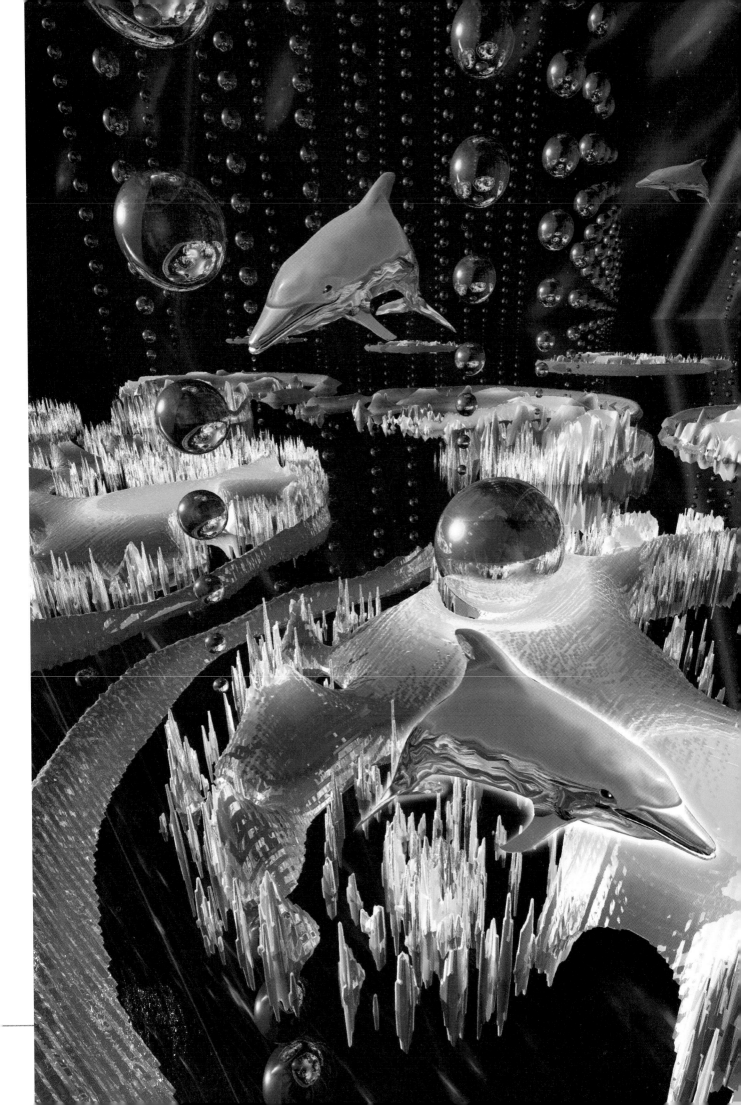

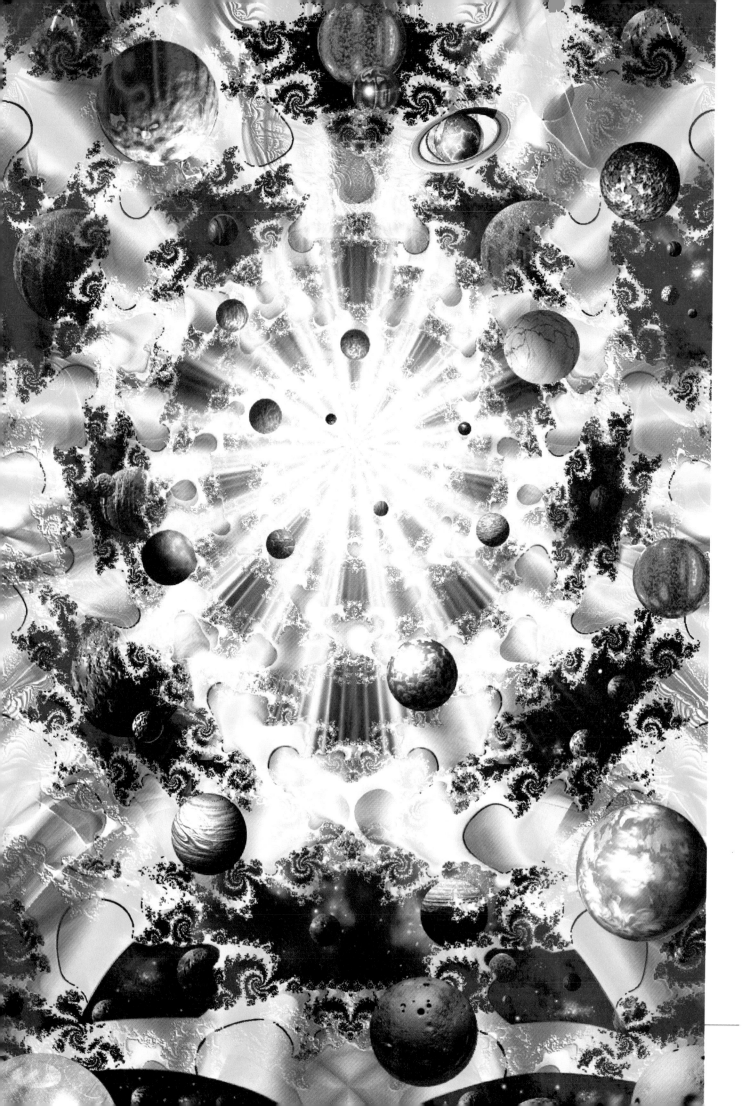

'The beauty of computers in the state they've arrived at now is that they let every artist express their individuality. We all use the same programs but the results can be completely different. Computers have become a visionary tool, a very intuitive medium. There is a lot of creative accident involved. In creating a landscape, for instance, the textures and light cannot be fully controlled. You don't know quite what will happen when the light source is introduced any more than a photographer does when waiting for the sunrise.'

Ziewe finds that the visual language of his computer art seems to be understood by a wide section of the population, who may be loosely labelled as New Agers, and who have taken motifs such as crystals, dolphins and fractals to heart. Fractals in particular, which play so large a part in Ziewe's pictures, have become an integral part of the iconography of the 1980s and 1990s, only made possible through the use of computers. In Jürgen's opinion, fractals have probably done more than anything else to open people's eyes to the artistic potential of the computer medium.

Universal Being 1994 ▶
Card: Inner Eye Publishing
Programs: MandelZot, Strata Studio Pro, Photoshop

The spiral drift of the fractal background prompted the feeling of something being created. Being such universal forms, fractals lend themselves to cosmic ideas. The terrain on the planets was also generated with fractals from the MandelZot program Ziewe used before acquiring KPT Fractal Explorer.

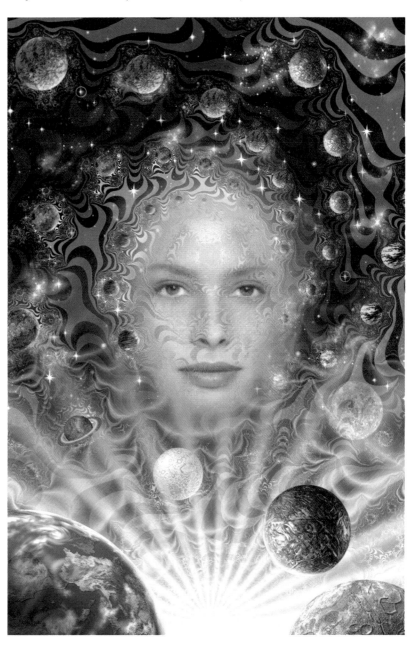

◀ **Big Bang** 1995
Poster: Unpublished
Programs: KPT Fractal Explorer, KPT Gradient Designer, KPT Bryce, Photoshop

The white light of consciousness at the centre and the mandala-like effect are recurring themes in Ziewe's pictures.

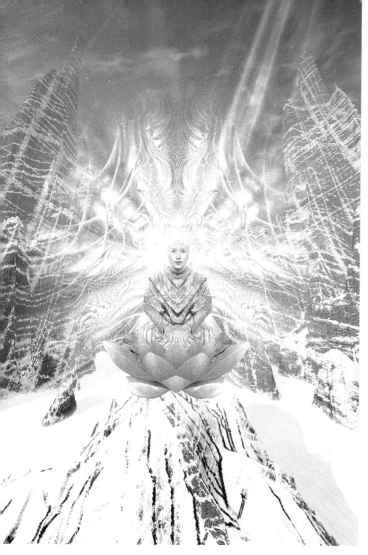

Fractals – the swirling, intricate patterns arising from the mathematics of chaos – are the building blocks of these pictures, the 'golden thread' that runs through them. Although it is not always obvious, they appear in various forms in over 80 per cent of Ziewe's art. However, he only uses them illustratively – for generating textures, landscapes and background patterning – believing that the day they could be admired purely as pictures in their own right has passed.

Om 1995 ▶
Card: Unpublished
Programs: KPT Fractal
Explorer, Photoshop

*Towards the centre of the picture,
all form ceases, reflecting the aim of
meditation which is to move beyond
creation to pure consciousness.*

▲ **Buddha** 1995
Card: Unpublished
Programs: KPT Fractal Explorer,
KPT Bryce, Morph, Photoshop

*Inspired by a picture Ziewe saw in India of the
Hindu god Krishna meditating in similar conditions.
To this day, Tibetan monks meditate for long
periods in freezing conditions and not only do they
not freeze to death, but the snow melts around
them. The monk's face is a combination of two
different portraits morphed together.*

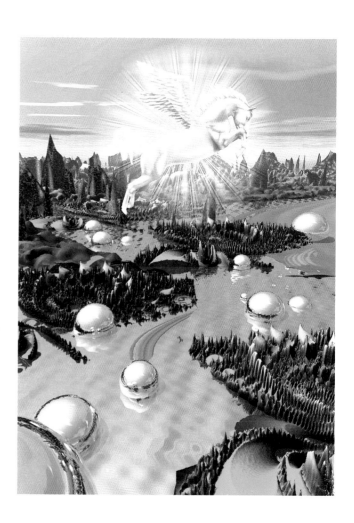

Home of the Pegasus 1995 ▶
Card: Inner Eye Publishing
Programs: KPT Gradient Designer,
KPT Bryce, Photoshop

*Although presented here as a 2D scene, this
landscape has a 3D existence within the
artist's computer, with an infinite number of
possible viewpoints, just as if the mystic
creature had been photographed in some
equivalent natural setting.*

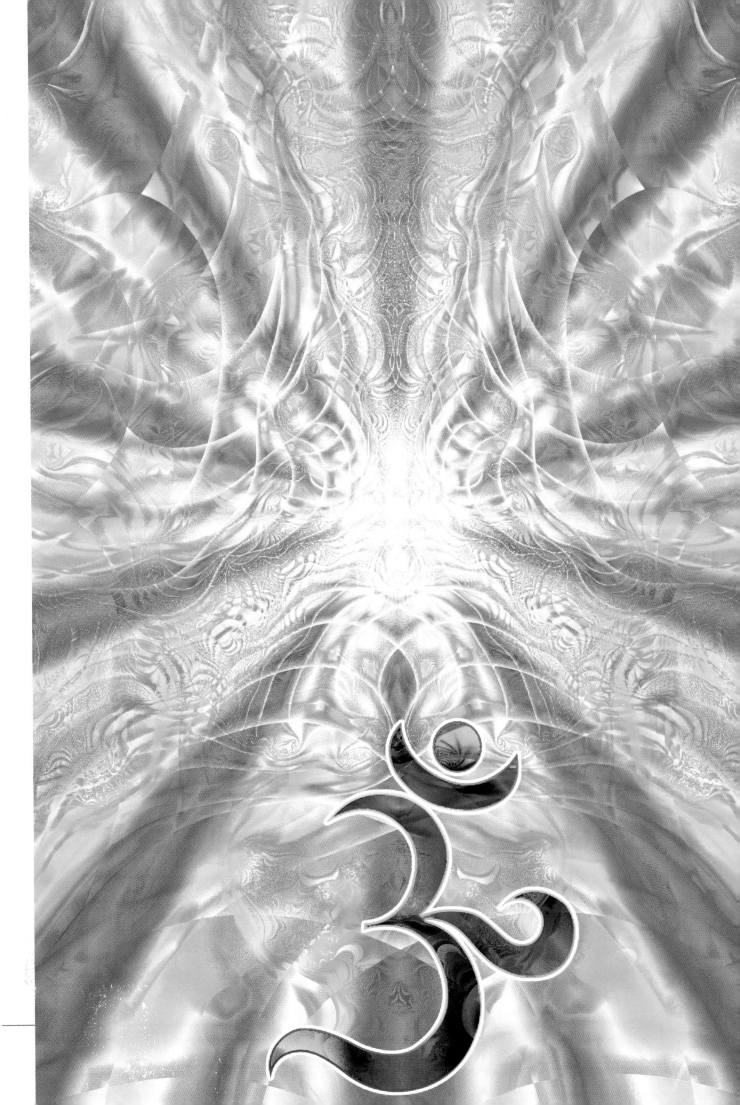

Geometrics and Beyond

Computers have a startling capacity to create pictures with a revelatory impact, which Ziewe suggests may be because they use pure light to create their images. The effect is close to that reported in visionary experiences and was previously perhaps best captured in stained glass, which has long been employed in cathedrals and other temples to conjure a spiritual atmosphere and lift people's imaginations out of the mundane.

Crystal Visions

One enormous advantage computers offer over the airbrush or any more usual means of creating images is when it comes to portraying clear or mirrored spheres. To achieve the degree of clarity and realism of the computer images any other way, would take not only a mind-numbing stretch of the imagination but infinite patience with minute detail, whereas the computer does it at the touch of a button.

Not all results are so easily achieved, however, and many of Ziewe's pictures take as long to create as if they were produced conventionally. When it comes to painting dragons, for instance, he feels at a distinct disadvantage beside other fantasy artists because he has to construct them limb by limb, before even beginning to consider how

◀ **Crystal Vision VIII** 1992
Card: Inner Eye Publishing
Program: Photoshop

Despite its title number, this picture was Jürgen Ziewe's very first piece of computer art, from which all the rest stems. It was also the first of a set of eight images inspired by a visit to the annual Festival of Mind, Body and Spirit in London, where crystals of every imaginable kind were on display. Although the patterning is far simpler than in his current work, he already found unpredictable chance effects emerging which is part of the lure of creating with computers.

Crystal Vision VI 1992 ▶
Card: Inner Eye Publishing
Program: Photoshop

they might be deployed in a picture. It is a case of swings and roundabouts.

As an abstract painter, Wassily Kandinsky was, and still is, Ziewe's great hero. In fact, he applied to the Hamburg Academy in Germany because that was where Kandinsky's last surviving pupil was teaching. Given that there were about a thousand other hopefuls applying for just thirty places, Jürgen felt lucky to be accepted.

His first batch of Kandinsky-style paintings was, however, completely slated by his teacher, which led to Jürgen burning the lot and plunging into depression. He abandoned painting for a while and took off to India to clear his head, as one did in those days. On his return to Germany he decided to train instead as a Rudolf Steiner teacher. In 1974 he married his English girlfriend Julia and when she became homesick a year or so later, they moved to Bournemouth on the south coast of England.

While waiting to take up a course in art therapy, he immersed himself in painting again, this time beginning with water-colours. Artistically, this period in Bournemouth, and later in St Albans, where he took the course at the Hertfordshire College of Art and Design, was one of the happiest of his life. He produced hundreds of pictures,

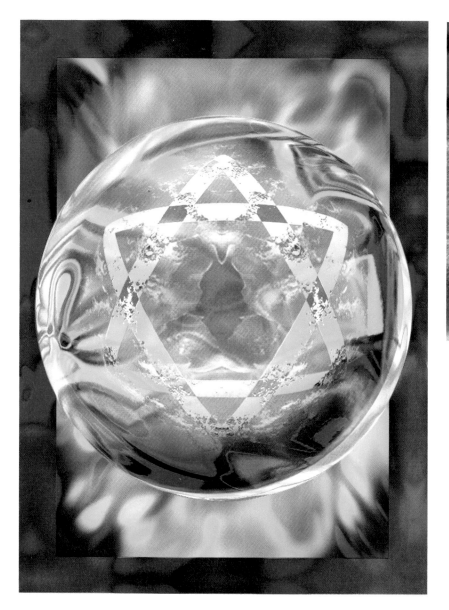

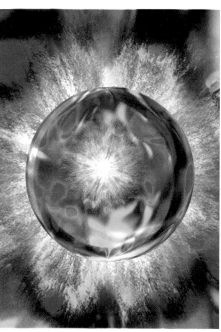

▲ **Crystal Vision III** 1992
Card: Inner Eye Publishing
Program: Photoshop

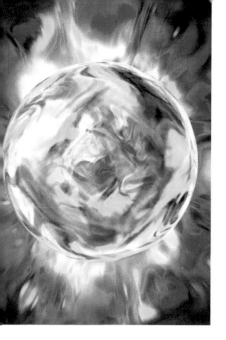

using everything from oils to household emulsion applied to almost any kind of surface, including carpet backing, cardboard and wallpaper – often working on a very large scale with dimensions of about three metres across. These pictures were wonderfully satisfying for Jürgen but did not prove as popular with the art-buying public. In fact to date, he has only ever sold one of his abstract paintings. However, they taught him much about art and design which came in useful later:

'In particular, I learned about the absolute honesty required in painting. You lay down a colour, then sit back and see what your instinctive reaction is, lay down another colour and so on. Some people think there's nothing to it, but you have to be completely honest with yourself.'

More practically, his design knowledge led to securing work as a graphic designer for various small companies, and eventually landed him a job as internal Art Director with the Woolwich Building Society based in Worthing on the English south coast. He and

▲ **Crystal Vision V** 1992
Card: Inner Eye Publishing
Program: Photoshop

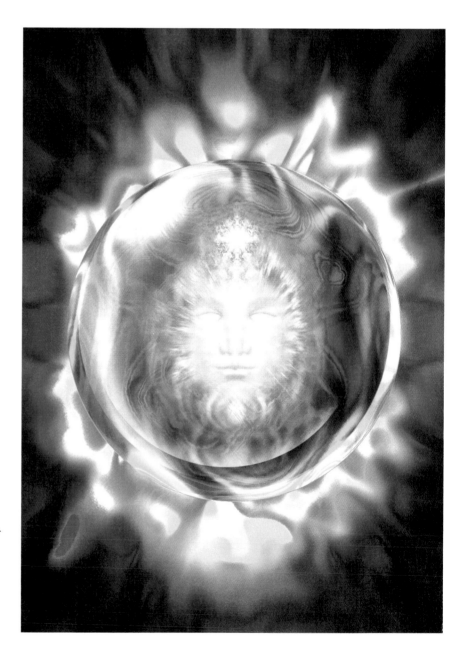

Crystal Vision I 1992 ▶
Card: Inner Eye Publishing
Program: Photoshop

The most popular of the series, possibly because it is less abstract than the others.

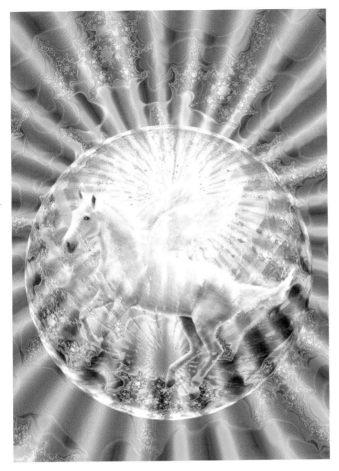

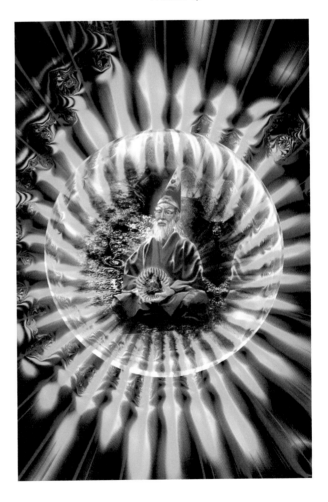

◄ Pegasus 1994
Card: Inner Eye Publishing
Programs: KPT Fractal Explorer,
Photoshop

*One of Ziewe's 'New Dawn' range of
cards in which recognizable subjects
were introduced into crystal spheres.*

▼ The Wizard 1994
Card: Inner Eye Publishing
Programs: KPT Fractal Explorer,
Photoshop

his wife had moved there to raise their family. As a graphic
designer producing company brochures, annual reports and
the like, he found the main difference from abstract
painting was that the design involved juggling blocks of
text and illustration rather than purely colour.

After he had been working for the Woolwich for twelve
years, redundancy threatened. Ziewe was the only one in
the office who was pleased at the prospect because he was
restless for a change and it also meant a nice fat
redundancy cheque which could help launch him in a new
career direction. As the day approached, he grew more and
more excited and when his last day at the Woolwich finally
arrived, Jürgen rushed out and blew a large chunk of the
money on computer gear and programs.

In the run-up to redundancy he had created the 'Crystal
Vision' cards in this section, which he now printed and
published – they were an immediate success. In fact Ziewe
was quite taken aback by the enthusiasm they met – most
shops quickly sold out and re-ordered. The cards also
operated as a huge mailshot, bringing in other work as well
as encouraging him to explore this new medium further.

Daybreak 1994 ▶
Card: Inner Eye Publishing
Program: Photoshop

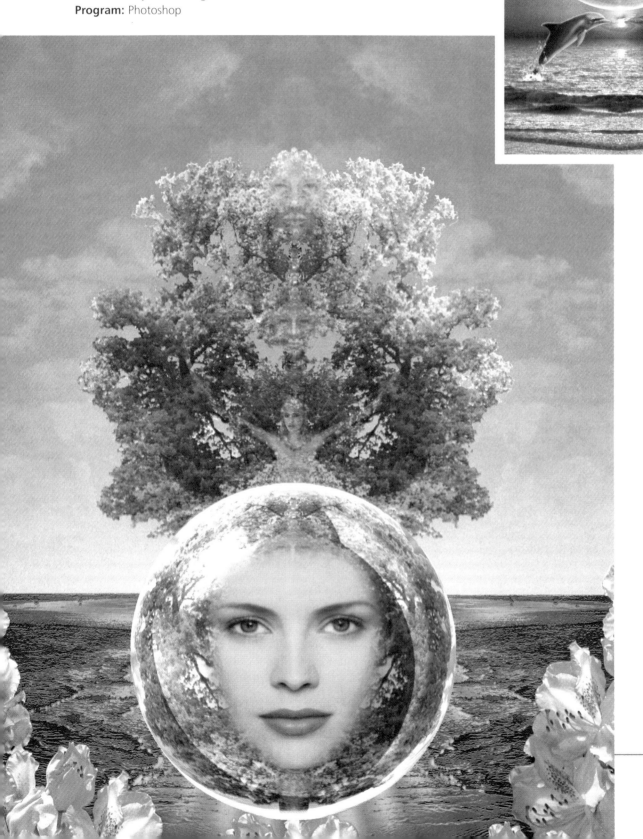

▼ **Tree of Life** 1994
Book cover: *Every Woman a Witch* (Foulsham)
Card: Inner Eye Publishing
Program: Photoshop

Pyramids

Following the success of the first set of crystal cards, the question of what to do next arose. Something different, yet with hopefully the same appeal, was needed and after a while pyramids suggested themselves as a suitable theme – having a simple geometry with strong symbolic overtones. They sold quite well, in greater numbers than the first set of cards, but this had more to do with improved distribution. The pyramid cards didn't generate quite the same level of enthusiasm and nudged Ziewe towards pictures that tell more of a story. They did, however, prompt Athena, already publishing Ziewe's work, to commission a pyramid poster.

The pyramid cards also mark Ziewe's first use of fractals, generated from the MandelZot 2.0 program, which cost him practically nothing. It was supplied by a company selling what are known as Public Domain programs, which means there is no copyright on them, often because they have been produced purely for the fun of it. You can often pick up such programs free with magazines.

Jürgen was fascinated by computers from the outset and bought one as soon as they became available in the High Street. His first was a Sinclair Spectrum, for which he learned the BASIC language and wrote a simple graphics program which allowed him to play with symmetrical patterns.

▼ **Pyramid Peak** 1993
Card: Inner Eye Publishing
Programs: MandelZot, Strata Studio Pro, Photoshop

This set of pictures marked the artist's first use of the Strata Studio Pro program. An extension to the main program was used to model the landscape, which although it has a certain charm of its own, now seems rather crude to Ziewe.

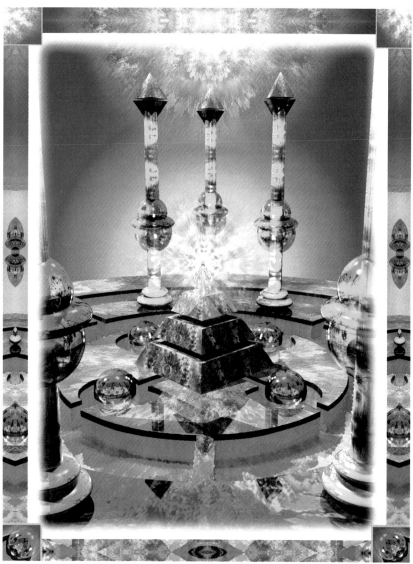

◀ Water of Life 1993
Card: Inner Eye Publishing
Programs: MandelZot, Strata
Studio Pro, Photoshop

*An earlier draft of this picture showed a
female in a bikini swimming in the water,
which somehow looked ridiculous. She was
replaced by this 'Eternal Feminine' figure,
who also appears in other pictures.*

Magic Eye 1994 **▶**
Poster: Athena
Programs: KPT Fractal Explorer,
Strata Studio Pro, Photoshop

*Commissioned by Athena in anticipation of
a surge of interest in pyramids due to the
film Stargate. However, the film's release
was delayed for a year and the poster had
to sink or swim on its own merits.*

◀ Immortality 1993
Card: Inner Eye Publishing
Programs: MandelZot,
Adobe Illustrator, Strata
Studio Pro, Photoshop

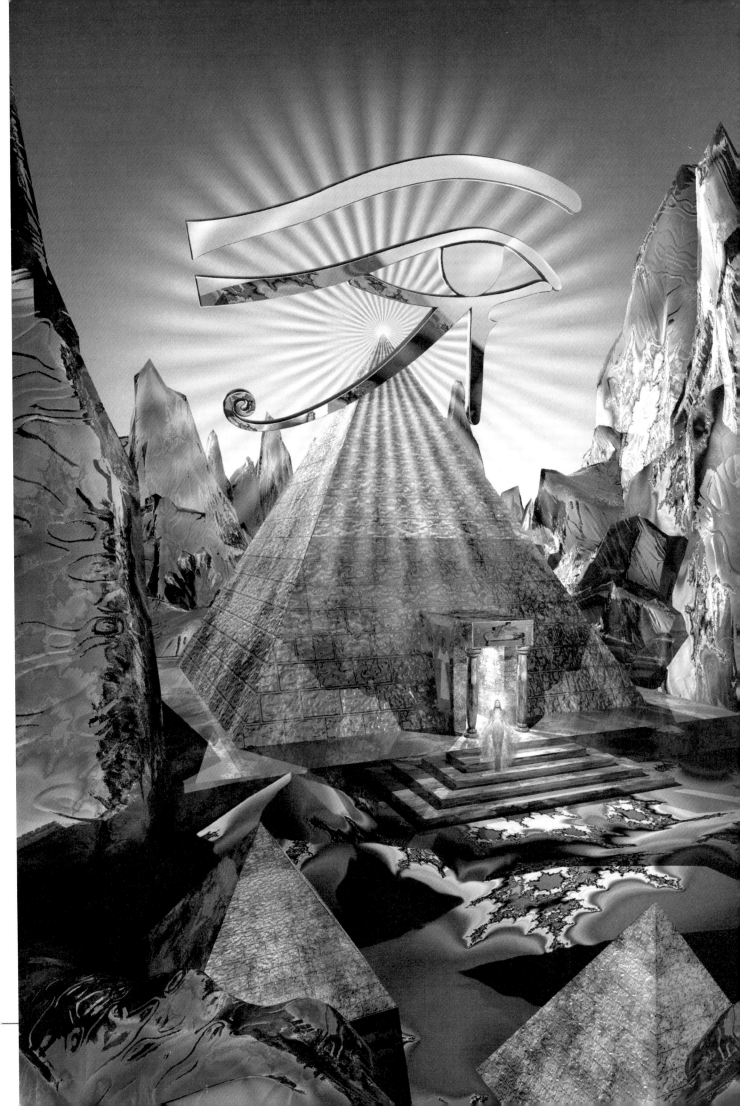

He was further inspired in the early 1980s by a BBC *Horizon* programme 'Painting by Numbers', which showed how graphic line models of 3D objects could be generated, then freely rotated and examined from any angle, before being fleshed out once the angle of view had been chosen. Although these techniques were primitive by today's standards, having no real graphics programs and a limited range of colours, they were tremendously exciting at the time. The only problem was that the cheapest machine then able to perform such tricks cost in the region of £10,000, so Jürgen knew he would have to wait for a while.

Far Countries

For his third range of cards, issued under the banner 'Far Countries', Ziewe chose a more fairytale mood. Several of them used his younger daughter Martina as a model and they show a more adventurous use of fractals than before.

One problem with computer art is that the initial outlay on both hardware and software can be daunting. There are occasional windfalls such as the MandelZot fractal program, but most of the tools of this art are expensive. An advantage of Ziewe's job

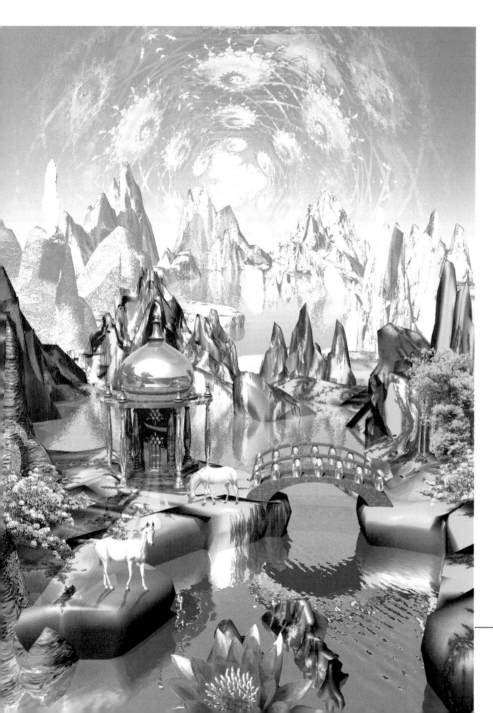

◀ **Unicorn Garden** 1993
Card: Inner Eye Publishing
Poster: Athena
Programs: MandelZot, Swivel 3D, Strata Studio Pro, Photoshop

The mountains in the background were modelled in the now obsolete Swivel 3D program, which produces very pleasing organic shapes. Strata Studio Pro can be used for mountains but it is trickier to achieve the same effects.

The Oracle 1993 ▶
Card: Inner Eye Publishing
Poster: Wizard & Genius
Programs: MandelZot,
Strata Studio Pro, Photoshop

The floor uses the same texture as in
Wizard's Cave (page 25) but with
different mapping. The flames were
painted in more or less manually with
the Photoshop airbrush.

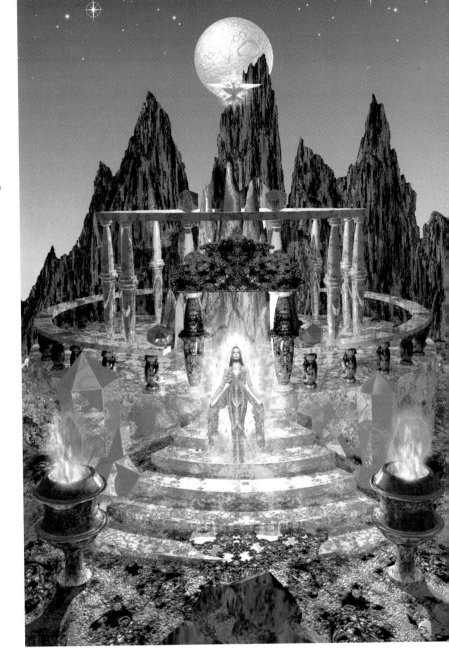

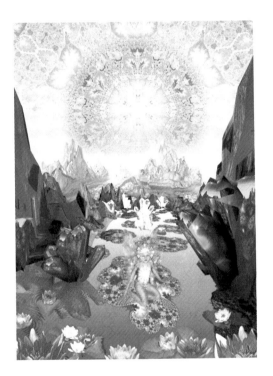

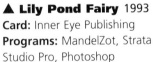 **Lily Pond Fairy** 1993
Card: Inner Eye Publishing
Programs: MandelZot, Strata
Studio Pro, Photoshop

at the building society was that it gave him access to their Apple Mac
computers, which were then the state of the art for graphics, so when it
finally came to buying his own equipment he knew more or less what was
needed.

His graphic skills proved to be very useful when he produced a full-page
advert in *Creative Review* for the Apple Centre in Croydon. This assignment
led to the acquisition of his first really practical computer, because for
payment they presented him with an Apple Mac IIFX on which the 'Crystal
Vision' cards were created. Ziewe published the cards and with the rest of his
redundancy money bought a Macintosh Quadra 900 plus a scanner, a 650
Megabyte optical disk drive and a DAT tape drive, on which he produced the
'Pyramid' and following cards. Later he added a 32 Megabyte memory to the
computer and a 1 Gigabyte hard disk drive, which took the Quadra about as
far as he felt it could go. Many of the pictures produced on this machine

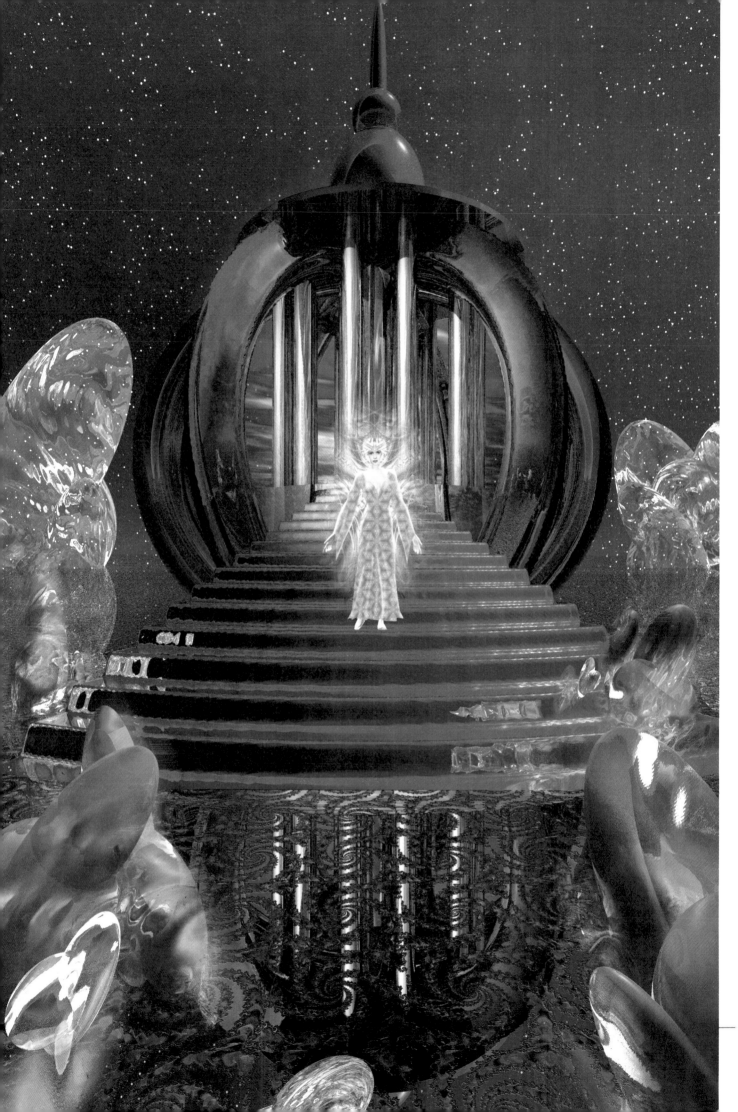

The Swans 1993 ▶
Card: Inner Eye Publishing
Programs: MandelZot,
Strata Studio Pro, Photoshop

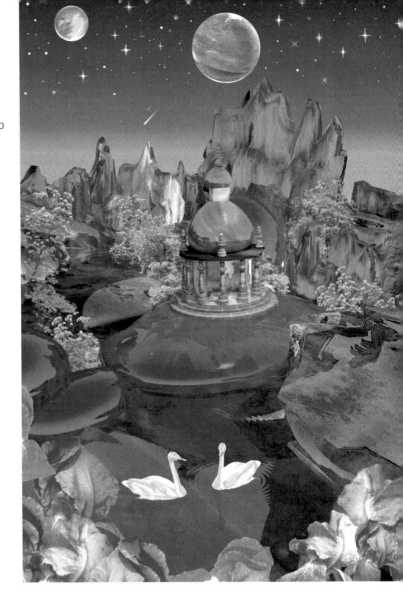

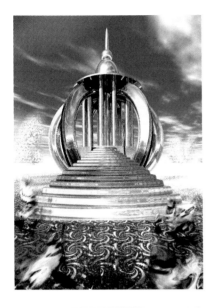

▲ Temple of the Night
Sketches

Two examples of how the mood of a picture can be changed dramatically by playing with the settings for sky and atmosphere. The problem then is deciding which combination to choose.

◀ Temple of the Night 1996
Private work
Programs: KPT Fractal Explorer,
KPT Bryce Strata Studio Pro, Photoshop

could have been produced on the IIFX, even some involving 3D modelling, but they would have taken much longer.

Later, following the success of his Athena posters and feeling particularly flush one month, Ziewe invested in a Power Macintosh 8100 with an 80 Megabyte RAM and 120 MHz RISC processor. He later expanded its memory to 140 Megabytes. This computer can take up to 256 Megabytes of extra memory, but eventually Jürgen will probably upgrade his equipment rather than extend it to its limits. As it stands, the Power Mac is eight to ten times faster than the Quadra and is now what he mostly works on – using the Quadra as a backup and the IIFX as an office machine to run the business side of his life. For anyone seriously interested in exploring 3D modelling, the Power Mac – with as much additional RAM as possible – is what he would recommend, as this can comfortably handle all the main programs such as Bryce, Strata Studio Pro, Raydream and Sculpt 3D. If speed is not an issue, smaller memory machines can be used to some extent but may not be able to create pictures to the required size and complexity.

The Power Mac has proved a good investment, but what Jürgen didn't realize when splashing out on it was that he was spending his family's entire

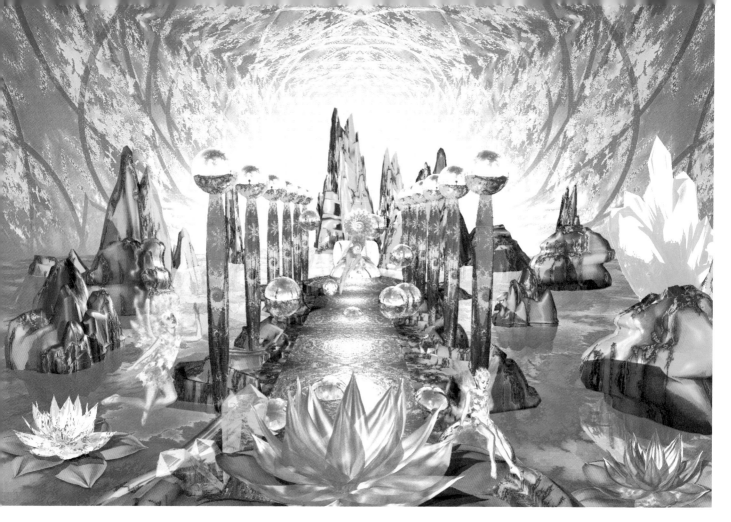

▲ Fairy Queen 1993
Card: Inner Eye Publishing
Programs: MandelZot,
Adobe Illustrator,
Strata Studio Pro, Photoshop

To achieve this patterned sky by any
other means is almost inconceivable.
Ziewe used to attempt similar effects
by hand (see below) but was rarely
satisfied with the result.

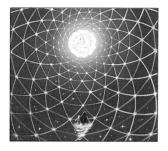

▲ Illustration for
Asuloca 1982
Airbrush 420mm x 450mm
An idea Jürgen had thought up for a
children's fantasy novel.

income for the next few months:

'Going freelance was a new experience for me. When you're used to earning a salary, budgeting is easy. If you want to buy a video recorder or something like that you do a bit of overtime – you can do what you like with any extra money. To then go freelance and be paid erratically can throw you a bit. If you get a cheque for £10,000 one month, it's easy to imagine it will happen every month. It takes time to learn to treat this kind of work as a business.

'I was a bit blasé about the economics of it at first. For a while I was doing so well I believed I could turn work down, but I soon learned about the insecurity of freelancing. I really look at spending very carefully now. Even the odd ten pounds or new piece of software has to be justified as paying itself back in the next three months. I've even learned to haggle with suppliers. I came to realize that business doesn't proceed in straight lines. But of course, taking risks is part of the fun, it wouldn't be the same without the threat of disaster.' He now aspires to a Multiprocessor Mac when financial conditions or courage permit.

Insecurities aside, one of the great bonuses Jürgen has found in going freelance is being able to get up at six o'clock in the morning and go immediately to work in his dressing gown. When clients ring up hours later, they have no idea they are talking to someone who is unshaven and still in his pyjamas. He just hopes videophones never catch on!

Wizard's Cave 1993 ▶
Card: Inner Eye Publishing
Programs: MandelZot,
Strata Studio Pro, Photoshop

This was the first of the 'Far Countries' series. It was also Ziewe's first cave picture and the start of a new obsession. The wizard was developed from an old photograph of a Buddhist monk, with Jurgen's own hands holding the crystal. The symmetrical map of the ground texture caused some interesting and unexpected effects. The whole scene was computer-generated in Strata Studio Pro, including the emeralds, which are programmed to refract light to the same degree as the real thing.

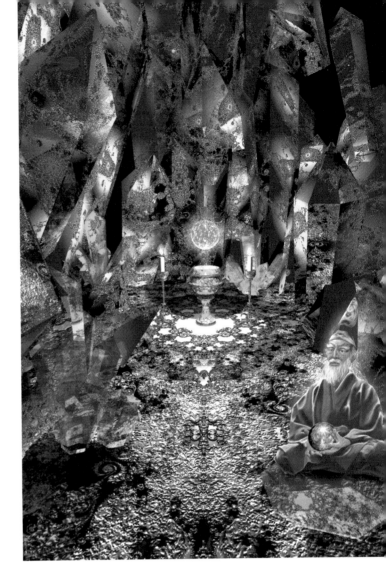

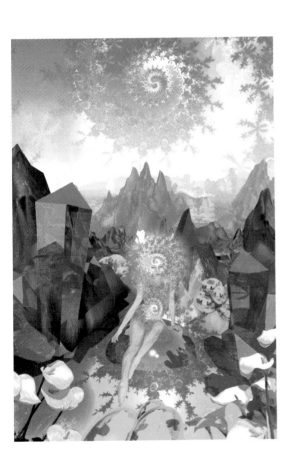

▲ **The Dawn Goddess** 1993
Card: Inner Eye Publishing
Programs: MandelZot, Strata
Studio Pro, Photoshop

Jurgen's younger daughter Martina, fractalized in Wonderland. The mood of the piece was inspired by mornings spent roaming the English South Downs with a camera in hand to capture the sunrise.

The Mermaid 1993 ▶
Card: Inner Eye Publishing
Programs: MandelZot,
Strata Studio Pro, Photoshop

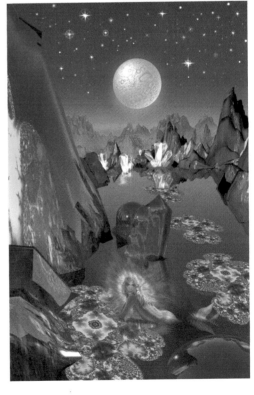

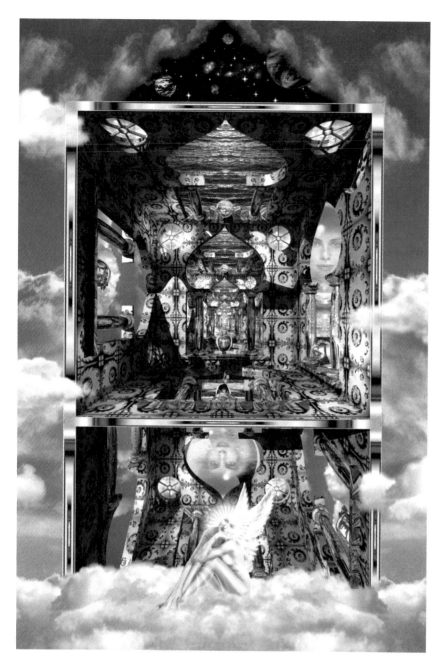

Poster: Cartel/Athena
Card: Inner Eye Publishing
Programs: KPT Fractal Explorer,
KPT Gradient Designer,
Strata Studio Pro, Photoshop

*Many of Ziewe's posters are team efforts in
that the concepts are either presented to him
by his clients, or at least discussed before work
goes ahead. In this case he just produced an
idea of his own and presented the finished
article for consideration. It is loosely based on
M.C. Escher's* Another World *in which three
different viewpoints of the same pair of
windows are shown simultaneously.*

Homage to Escher

Most of the pictures in this book were created in one or all of four main computer
programs – Adobe Photoshop, KPT Bryce, Strata Studio Pro and Fractal Design Poser.
Added to these are various extensions or filters – modules which plug into the
programs and can be operated from within them. Some of the filters are almost
separate programs in themselves, but they need to ride piggyback on something else.
Marrying different programs together like this makes for enormous flexibility, but they
can sometimes clash and bring the whole system grinding to a standstill.

Probably Ziewe's favourite extension is the KPT Fractal Explorer, which plugs into
the Photoshop program and has replaced the trusty MandelZot. Generating fractal
patterns from the Mandelbrot and Julia (named after the French mathematician
Gaston Julia) sets, Fractal Explorer enables you to zoom infinitely into any part of
them you choose, which feels very much like space exploration. Left to his own devices

Computer Study of ►
Escher's Waterfall 1995
Private Work
Programs: KPT Bryce,
Strata Studio Pro, Photoshop

*Although considered as a poster, it
was decided this was too close to the
original to work as more than a
study. A good example of how
computers don't necessarily save
time, as Ziewe estimates that the
month or so it took to produce was
probably longer than Escher spent on
the original. Retouching the water
was a particularly intricate process.*

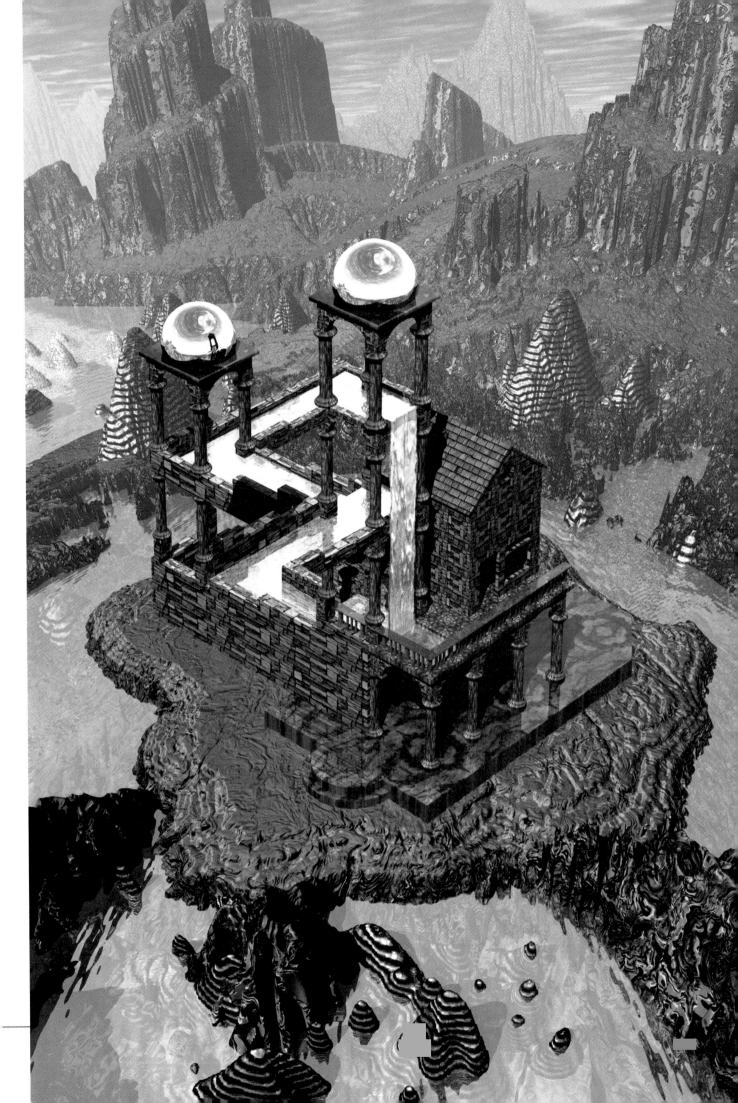

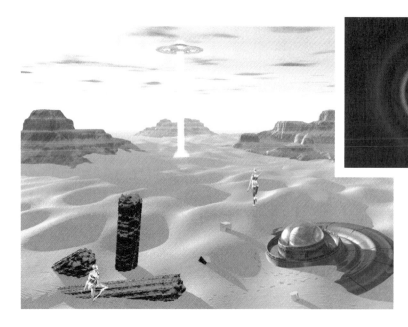

▲ Grayscale map
for flying saucer
in **Rescued**
(opposite)

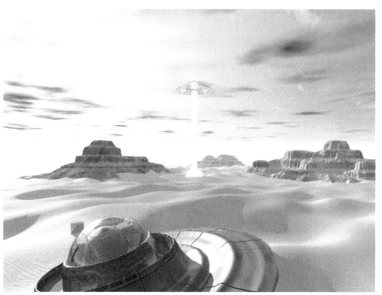

◀ Three Sketches for **Rescued**
(opposite)

*Background studies to illustrate the virtual reality
aspect of the composition. It can take days to create
a landscape background for a picture like this.
The flying saucer was painted initially as a grayscale
map of concentric circles in Photoshop (see above)
before being imported into KPT Bryce for conversion
into 3D. Once a 3D landscape model had been
created from the pattern of circles, the ground level
was deleted and the image flipped and joined to its
mirror image to create the first stage of the flying
saucer, the bottom half being flattened for realism. A
sphere was then introduced and given a transparent
texture to create the dome and a texture map was
devised and applied to the rest and – Hey Presto! A
flying saucer any alien would be proud of.*

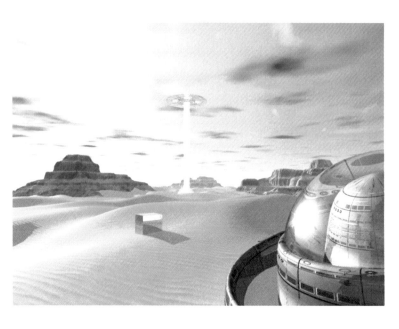

Rescued 1996 ▶
Poster: Cartel/Athena
Programs: Fractal Design
Poser, KPT Bryce, Photoshop,
Strata Studio Pro

*Very loosely based on Escher's House
of Stairs, the idea being that the
flying saucers have arrived to break
the treadmill tedium of everyday
existence. The figures were modelled
in Fractal Poser and the stairs in
Strata Studio Pro.*

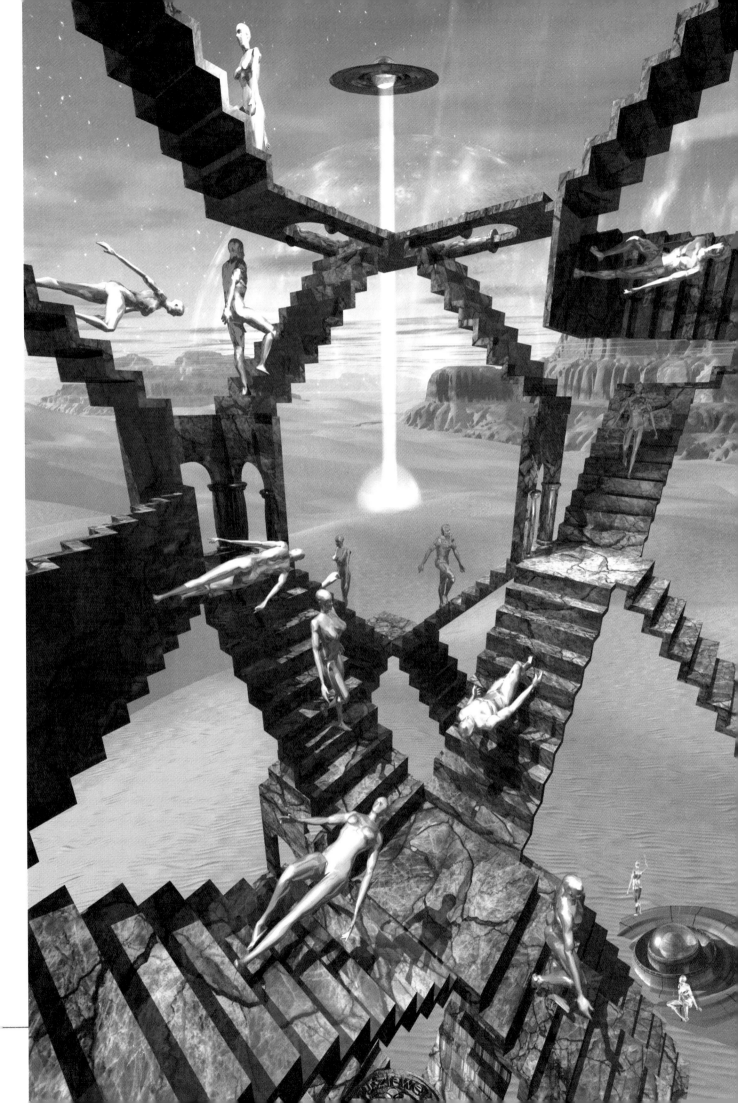

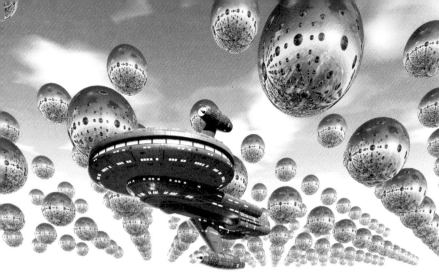

◀ **Inner Space** 1996
Private Study
Programs: KPT Bryce,
Strata Studio Pro, Photoshop

*One of several reinterpretations of
Escher's perspective studies.*

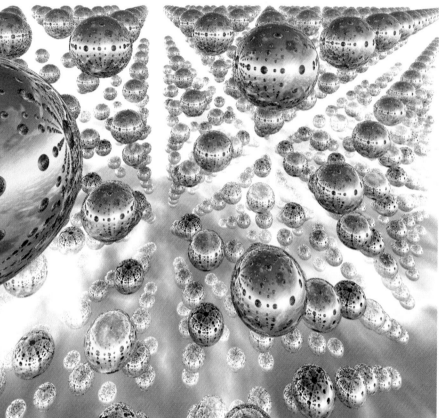

Ziewe could get lost in fractal exploration for days, so he has to set himself time limits.

Added to this facility are full-colour controls and a range of kaleidoscoping effects from another filter called Terrazzo. This filter produces an infinite variety of stunning tile patterns and Jürgen wonders why no tile manufacturer has yet used them to create a dramatic new look for the bathrooms of the 21st century.

Human figures which are not derived from photographs are created first of all in Fractal Design Poser, a Letraset program which Ziewe sees as the modern equivalent of the wooden human mannequin many artists keep in their studios.

For the most basic sketching, Poser breaks the human figure down into blocks which can be marched around the screen and put through their paces like toy soldiers. When the pose is set, the body shape is defined. The program lets you choose from a range of preset builds between about 20 kilos overweight to the same at the other extreme;

anything beyond these limits has to be worked out by the artist. This rough image can then be refined with options in Poser, but Ziewe generally prefers to transfer it as a DXF file to Strata Studio Pro for rendering, because it has better mapping and rendering controls. The DXF file uses a universal format designed specifically for transferring information across different 3D programs, or platforms. It saves the image as a wire-frame model, defining it with a triangular mesh which can be moved point by point to adjust and modify the form. When the wire-frame model is made solid it has a faceted look rather like a half-finished wooden carving.

Then the refining begins – the model is smoothed down and its texture and colour decided. Finally the camera angle is chosen and the lighting set up – very much as a photographer would set up a studio, except that it all happens within the computer. Shadows can also be introduced at this point, and reflections if the figure is to stand on a wet or mirrored ground. Finally the rendered image is transferred on a PICT file from Studio Pro into Photoshop, either into a new file for further consideration or into the picture background for which it is intended.

▼ **Spatial Study** 1995
Private work
Program: KPT Bryce

An improvisation on Escher's scaffolding.

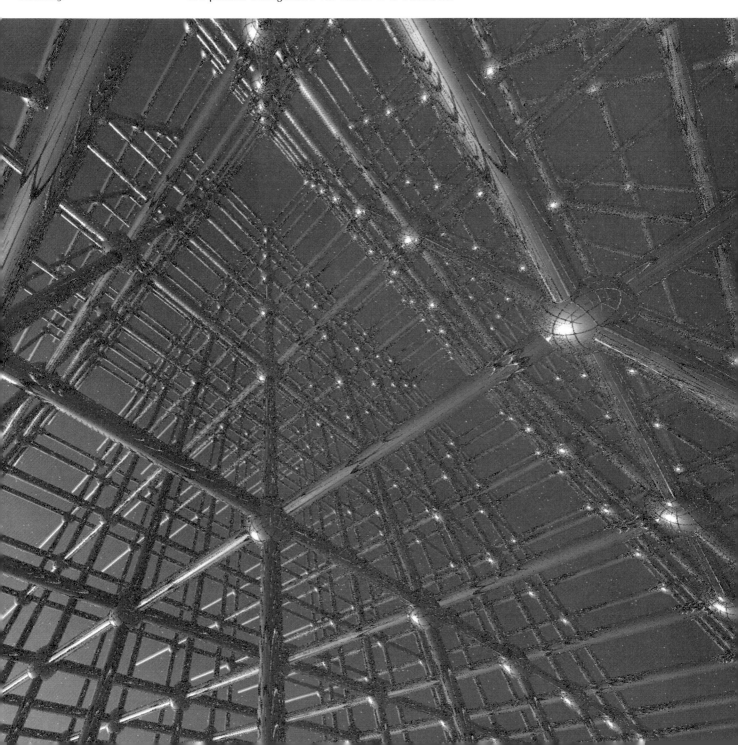

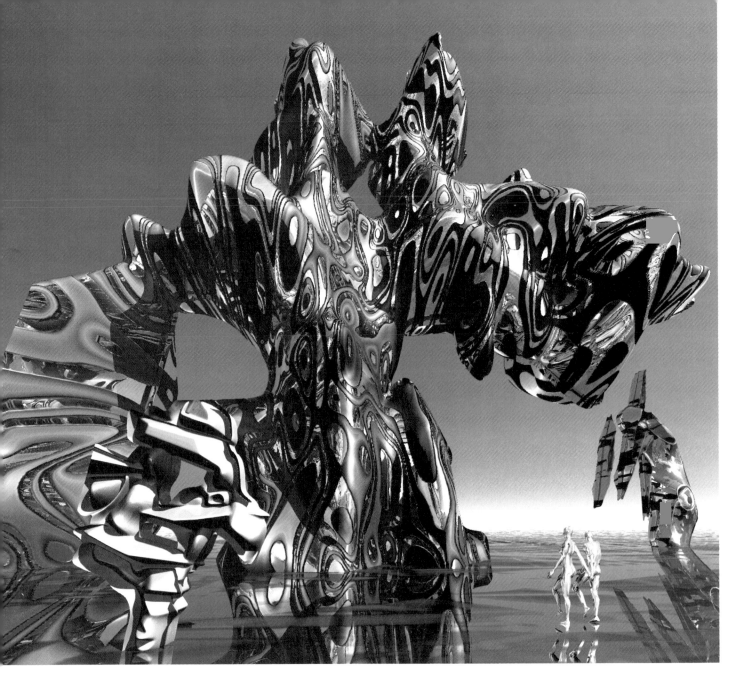

**▲ Venice Biennale
2525** 1995
**Private work
Programs:** KPT Texture
Explorer, Fractal Design Poser,
KPT Bryce, Strata Studio Pro,
Photoshop

*Ziewe's answer to Henry Moore. He
has always wanted to create abstract
sculptures on a large scale but been
put off by the practical complications,
such as having a suitable studio,
power tools and heavy-lifting
equipment. The setting is the famous
sculpture exhibition in Venice, after
the city itself has sunk into the
Adriatic.*

Virtual Sculptures

At the stage when Ziewe transfers his sketched figures into Photoshop for final
processing, they look very much like the slightly impersonal androids that wander
through so many of his pictures. Often he prefers to keep them like that because,
having been created wholly within the computer, they are consistent with their
surroundings. With computer images he likes to stress their origins, just as when he
painted with water-colours he liked to emphasize the wateriness of the medium. The
figures introduce a human presence and sense of proportion, but leave the placing in
time and space open to the viewer's imagination. Clothing and personalizing them can
detract from the dream-like spell of the imaginary landscape.

However, there are also times when something more personal is called for, as with
the Eternal Feminine who appears on page 21 and elsewhere. In such cases the image
will be enhanced in Photoshop with the airbrush facility, or by blending it with one or
more photographs using a Morph program. Clothing can also be scanned in from
photographs, but it is generally simpler to paint it from scratch, and pattern it by

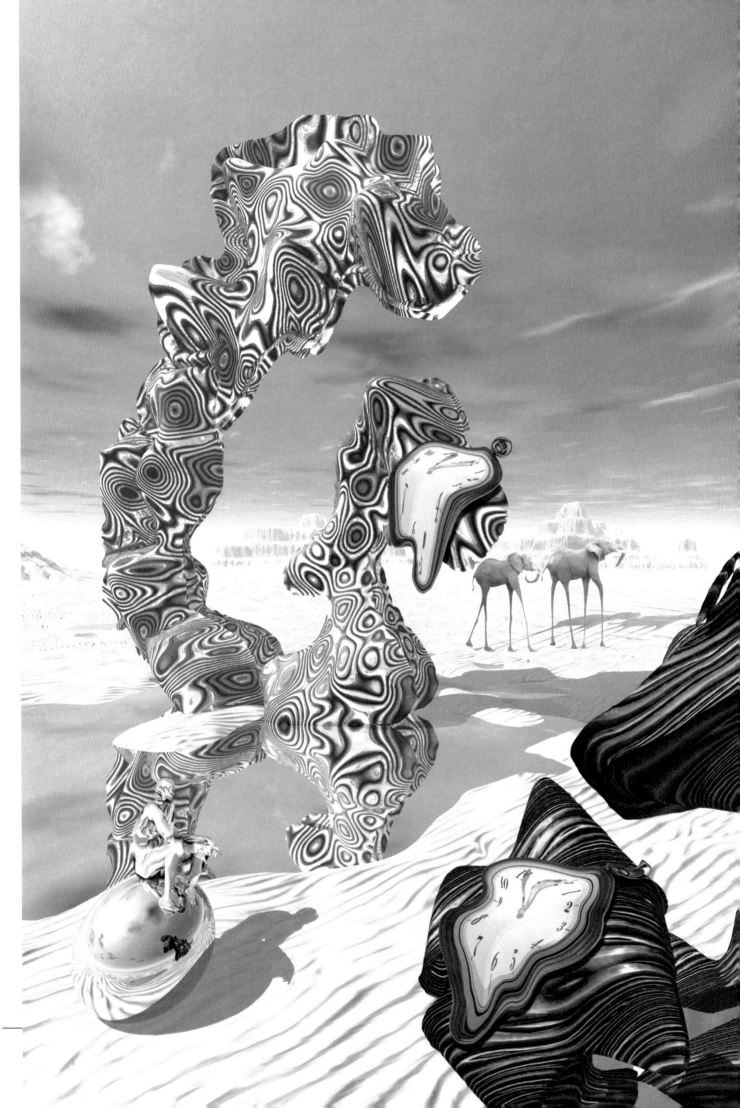

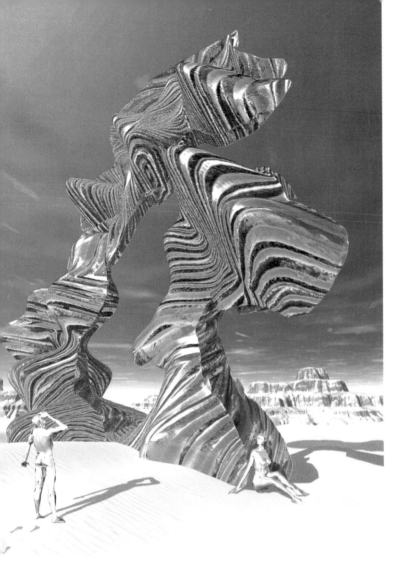

Fossils of a Lost Species
1996 ▶
Private Work
Programs: Fractal Design Poser,
KPT Bryce 2, Strata Studio Pro,
Sculpt 3D, Photoshop

*The result of an experiment to test out the
Bryce 2 program which enables you to
repeat shapes while varying parameters
like rotational angle, size, etc. It also
allows the easy import of objects from
other programs.*

◀ **Monument to a Lost
Civilization** 1996
Private work.
Programs: KPT Texture Explorer,
Fractal Design Poser, KPT Bryce,
Strata Studio Pro, Photoshop

kaleidoscoping some element of the surroundings. One great advantage of the
computer's virtual airbrush over the real thing is that there is no danger of it
splattering ink all over a picture at the last moment and ruining it! Also, there is much
greater freedom to experiment with colour schemes as the brush only determines the
position and density of colour, while the colour itself can be changed by the touch of
a button.

 Hairstyles can be a problem, however. Modelling hair from scratch requires the
computer to replicate the countless thousands of hairs on a head, which is technically
possible but rather a waste of energy. There are programs that can do this on Silicon
Graphics machines but using his existing programs, the results tend to look like
portraits of Medusa. The practical alternative is to paint the hair in manually or scan in
a suitable photograph.

◀ Previous Page
Waiting 1996
Poster: Unpublished
Programs: KPT Texture
Explorer, Flo, KPT Bryce,
Strata Studio Pro, Photoshop

Contemplation 1996 ▶
Private work
Programs: KPT Texture
Explorer, Fractal Design Poser,
KPT Bryce, Strata Studio Pro,
Photoshop

2 | Posters

It's curious how life sometimes works out. Jürgen Ziewe wanted to be a poster artist from the age of about five, when he lived on the fringe of the small town of Fürstenau in Germany.

Occasionally the family would visit an uncle in what seemed at the time to be the big city of Velbert, near Essen. It is actually no larger than Worthing where he now lives, but at the time it seemed the height of metropolitan sophistication.

Through his bedroom window the young Jürgen had a view of a large billboard which made an enormous impression on him. It was only advertising something as mundane as washing powder, but at the time it had a glamour that perhaps rubbed off from the excitement of the city, and Jürgen vowed that one day he too would make posters like that. Some forty years later the dream came true, and in a far more interesting way than he could have imagined as a child.

The cards he had been publishing caught the attention of the Athena company, who approached him about the possibility of doing some fractal backgrounds for posters. With a self-confidence that now seems rather reckless, and which led friends at the time to think him crazy, Ziewe said he was not interested in giving such a marginal contribution to other people's ideas.

That should have been the end of it, but a while later Athena came back with a more ambitious offer, which led to the highly successful range of posters shown here. They were produced on a

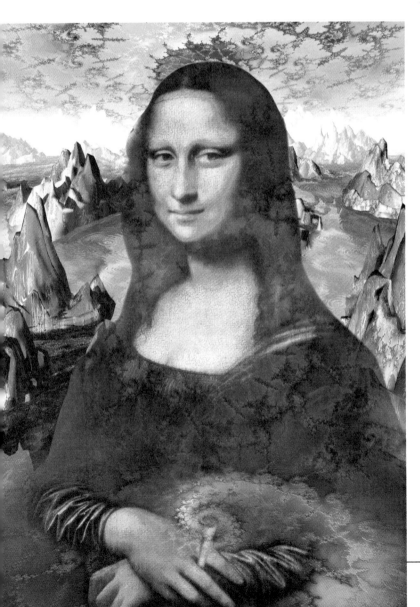

◀ **Mona Lisa** 1993
Poster: Athena
Programs: MandelZot,
Strata Studio Pro, Photoshop

*Jürgen's second Athena poster, which
was enormously successful, has appeared
on T-shirts and inspired several copies.
The landscape was modelled in a similar
style to the background of the original,
which was one of the first Renaissance
portraits to include a landscape. Close
examination of the large roll-up reveals a
crackling of the paint in keeping with the
rest of the figure.*

Universal Tear 1994 ▶
Poster: Verkerke
Programs: MandelZot,
Strata Studio Pro, Photoshop

*The title is as much a mystery to the
artist as anyone else, having been
dreamed up by the publishers.*

Day Trip 1993 ▶
Poster: Athena
Programs: MandelZot, Photoshop

Jürgen's first poster, based on an old black and white photograph which had to be coloured as well as improvised upon. It triggered a spate of other posters featuring trippy VWs and gave Jürgen a curious turn by appearing on the wall of someone's flat in EastEnders. Part of its success was attributed to the Thelma and Louise-type attitude of the two females.

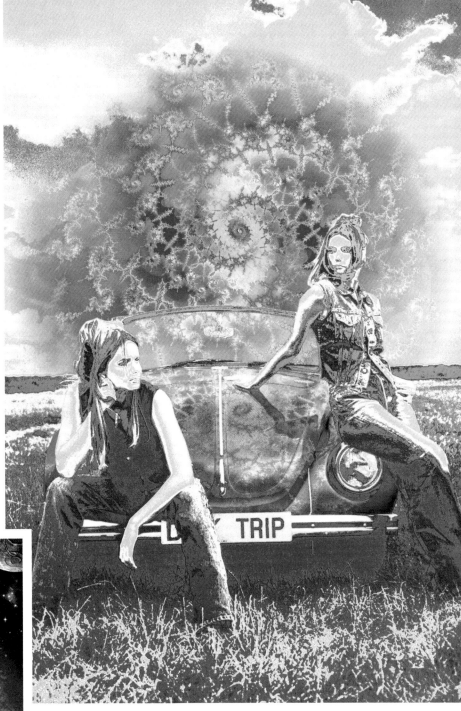

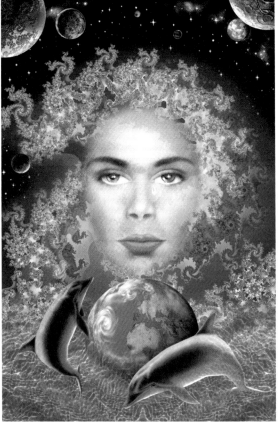

wave of enthusiasm because, for the first time in his life, Ziewe found himself being employed to do something he really enjoyed.

Producing the first Athena poster, *Day Trip* (above), was a wonderfully exciting experience, Jürgen never having tried anything quite like it before. The combination of creativity, co-operation and furious pace was a heady one, particularly when both this poster and its successor, *Mona Lisa* (opposite) were immediate hits. For a while it seemed to all concerned that anything Ziewe produced on his computer would also sell like hotcakes, but of course life is never quite that simple.

It was also his first professional experience of electronically manipulating other people's work, an old photograph for the first

poster and Leonardo da Vinci's painting for the second. Generally this is something he personally tries to avoid, not least because of complicated copyright laws, but with commissions like these that is the publisher's affair. There is also the moral question of pinching other people's ideas, which Ziewe has suffered from himself, having seen pirate copies of his posters for sale or used on rave tickets. The closest he comes to it himself is occasionally synthesizing portraits from magazines when he has no suitable picture of his own, but even this is rare. Some software companies do publish ready-made photographic reference libraries, but one has to read the small print carefully if intending to use the material commercially.

When Athena abruptly went out of business, the poster side was taken over by Cartel and the new group has continued publishing Jürgen's work. Martin Powderly, one of the art directors with whom he worked closely on his first posters, moved to the Dutch company Verkerke, providing a second outlet. A deal with Scandecor followed in 1995 and currently a couple of other publishers have produced posters which expose his work to a different market. To date Ziewe has had about thirty posters printed, most of which have reprinted several times; some of which have become classics.

He was one of the first people to create art posters wholly on the computer. In many ways it is less stressful than using conventional means, but the computer saves less time than people imagine.

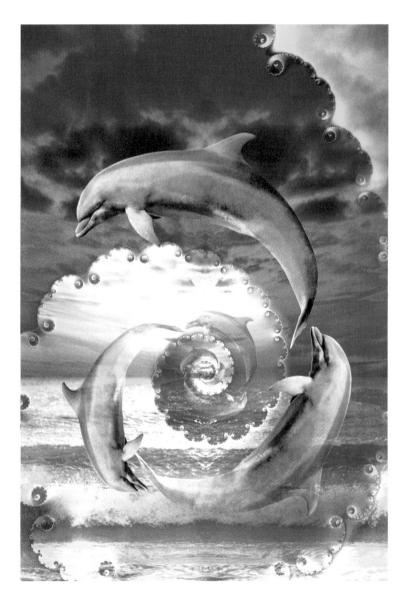

◀ **Dolphin Song** 1994
Poster: Cartel/Athena
Programs: KPT Fractal Explorer, Photoshop

For the technically minded, the background was based on the artist's library photographs, fractalized with Kai's Power Tools and brought together using Luminosity Controls in Photoshop. The view is that from Worthing beach, mirrored about a line down the centre. The concept was suggested by Cartel.

Global Warming 1995 ▶
Poster & card: Verkerke
Programs: Flo, KPT Bryce, Strata Studio Pro, Photoshop

A Flo program was used to melt the watch, which was modelled in Strata Studio Pro. Perhaps inescapably, the picture gets called Dali-esque.

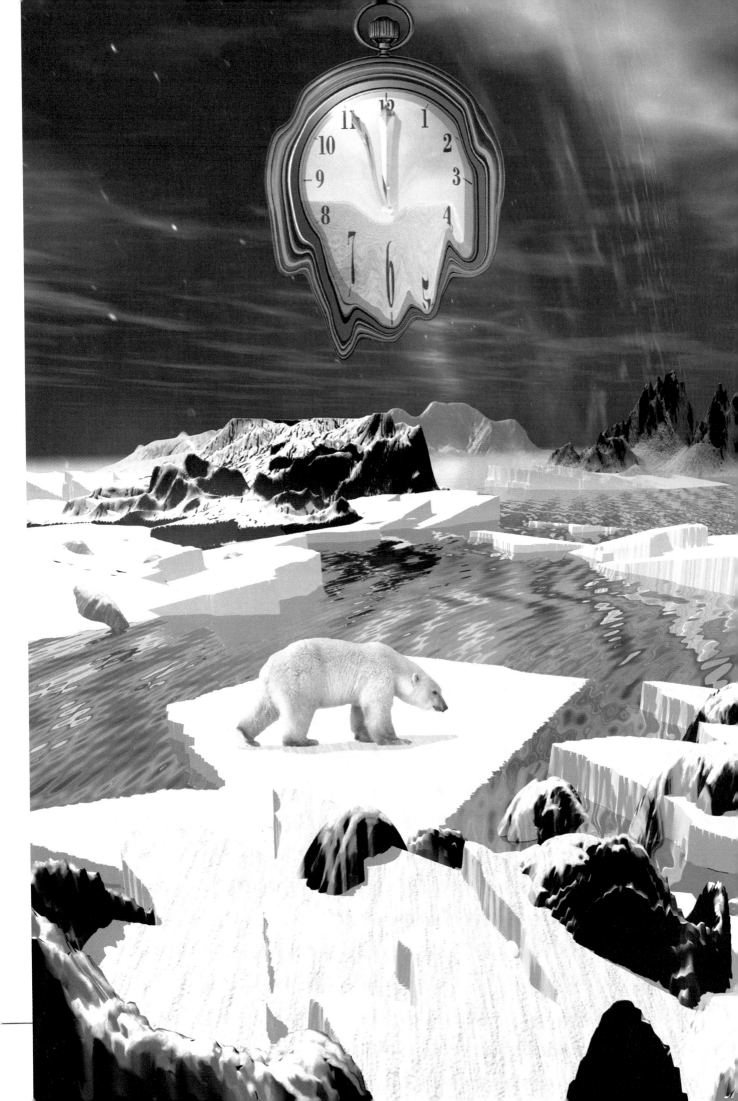

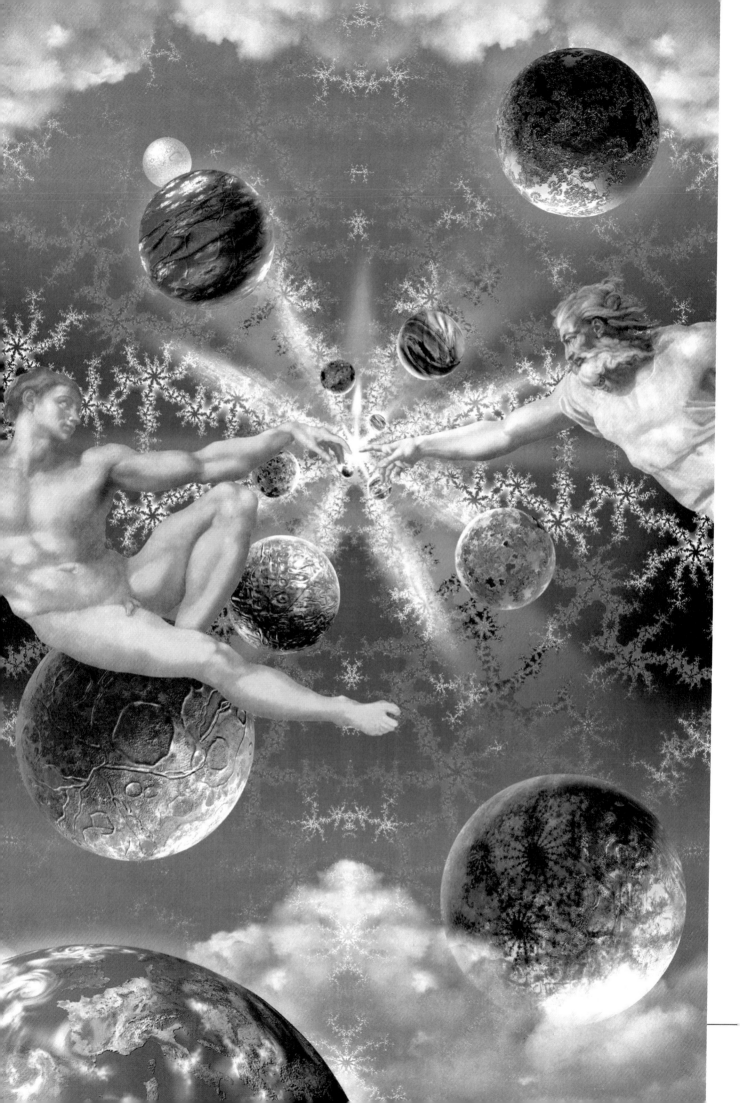

Che 1994 ▶
Poster: Verkerke
Programs: KPT Fractal Explorer,
KPT Gradient Designer,
Strata Studio Pro, Photoshop

The Art Director's concept. Originally, Che's
head was printed in gold but it looked too
much like a negative, so was changed to
black. The background, with its sunburst
suggesting a new political dawn, hints at
Soviet revolutionary art. In his youth Ziewe
went through a fervently left-wing phase
so it was doubly ironic being asked for this
postmodern rendering of idealism.

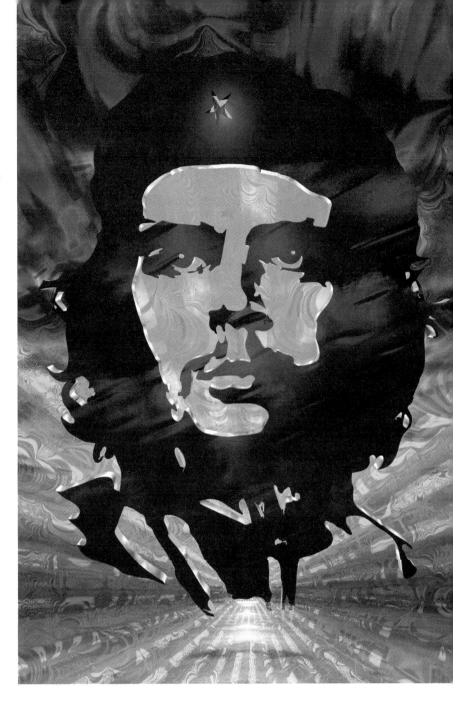

◀ **Creation** 1994
Poster: Verkerke
Programs: MandelZot,
Strata Studio Pro, Photoshop

The artist's own suggestion,
following the success of Mona Lisa.
It has also inspired flattery in the
form of close imitations.

There can be up to four main elements of the composition which can take two or
three weeks to bring together.

On the Quadra computer Ziewe was then using, rendering a scene for the earlier
posters took 150 to 200 hours, whereas on the PowerMac it would now take less than
a day. Rendering times obviously depend very much on the complexity of a picture.
Reflections, in particular, take a long while, but as a rough guide, typical times on
Ziewe's current equipment for images to be printed are 9 hours for an A3-sized print,
4 hours for A4 and 2 or 3 hours for A5 – although it varies according to how much
detail there is in the image.

The landscapes in Ziewe's pictures are usually created in KPT Bryce, which has almost
a cult following among computer artists. It is quite a simple program to use, as many
are in this field. At times, these programs can make creating a picture more like being
an Art Director than an artist, as they make it quite a short step between having a
concept and seeing it realized. Ziewe is all in favour of this:

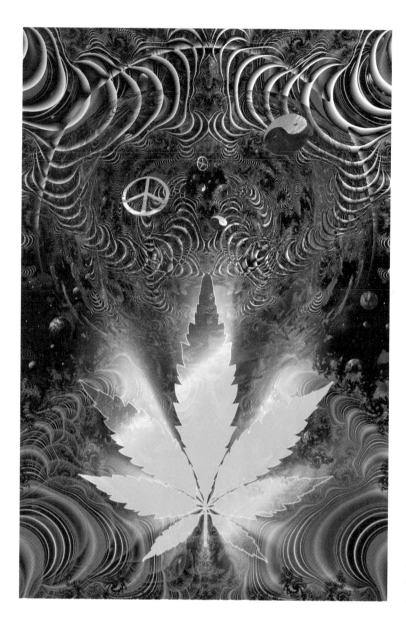

High Life 1994 ▶
Poster: Cartel/Athena
Programs: KPT Fractal Explorer,
Photoshop

*When Jürgen's younger daughter realized this
was not a peppermint leaf (as he had rather
coyly told his girls) she flew into a shock of panic
and fear. Convinced her father was a junkie,
she went and ransacked his studio for evidence
– and found a red-stained box full of the
enormous syringes used to inject ink into the
cartridges of his Canon colour printer. The
ensuing tearful trauma can easily be imagined.
His elder daughter Naomi, however, was less
worried that her dad was involved in advertising
the existence of illegal mood-altering herbs and
hung the poster on her bedroom wall. Jürgen's
own view of the matter is non-committal. He did
in fact ask for his name to be left off the poster,
because he did not particularly want to enter the
debate over soft drugs, but was not greatly put
out when no one remembered to do it.*

◀ **Spaced Out** 1995
Poster: Verkerke
Programs: KPT Fractal Explorer,
KPT Bryce, Strata Studio Pro, Photoshop

*This began life as a poster for MTV, whose logo
was replaced by the leaf for more mainstream
appeal. The various emblems spinning through the
fractal universe were suggested by the publisher.*

'Such programs are democratizing computer art in that almost anyone can use them
without knowing much about computers. The best new programs like KPT Bryce hardly
require you even to look at the manual.'

Creating a basic landscape using pre-tailored features in the program is not difficult.
In fact, Jürgen's children can do it and produce results that to the uninitiated look
pretty impressive. But surprisingly it also quickly becomes boring because all you are
doing is juggling elements created by other people. Creativity begins at the point
where boredom would otherwise set in, and there are a multitude of facilities within
the program which allow you to come up with something totally original.

Adobe Photoshop is another program Ziewe finds invaluable. It is one of the most
commonly used programs in the graphics business and has, in Ziewe's opinion,
revolutionized graphics as much as Gutenberg's press did the book industry a few
centuries ago. Photoshop is mainly used for post-production work, bringing together
and blending all the ingredients of a picture that have been generated elsewhere.
Occasionally it is used for creating elements for other programs, particularly KPT Bryce
if the scene is mainly landscape. To use Photoshop effectively requires a hard disk

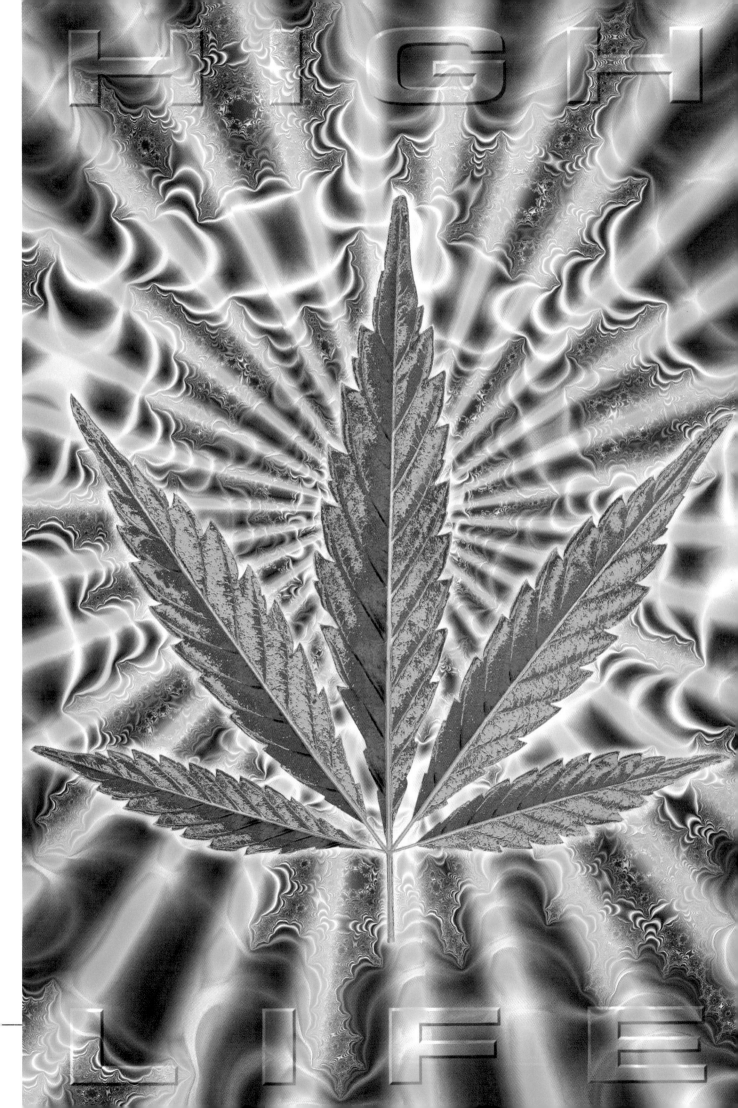

Metamorphosis II 1995 ▶
Poster: Unpublished
Programs: KPT Texture Explorer,
Morph, Photoshop

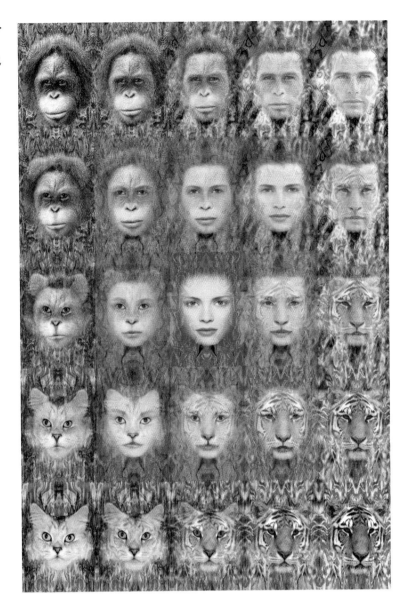

◀ **Metamorphosis** 1995
Poster: Cartel/Athena
Programs: KPT Texture
Explorer, Morph, Photoshop

*An idea prompted by being asked to
create some 'Magic Eye' pictures. As he
cannot see them himself, Ziewe had to
decline but decided to try something
that looks at first sight as if it might be
one. Interestingly, its popularity has
outlasted all the 'Magic Eye' posters
published at the same time. It contains
dozens of different images if you look
closely enough.*

capacity about six or seven times the size of the file you are working on –
something that needs to be remembered when considering buying a
computer for this kind of work.

Once the different elements are combined in Photoshop, the fun part
begins because there is enormous freedom to play with such things as
composition and colour, and a high-quality inbuilt airbrush to modify or
add to any effects. This contrasts with traditional painting in which these
elements have to be decided early on, and it is a major blow if you decide
that they need to be changed at the end.

A useful tool that can be used with Photoshop is a graphics tablet, an
electronic drawing pad that when used with programs such as Painter, can
emulate most traditional artists' media such as the standard paintbrush
with either oils or watercolours, airbrush, marker pen, felt tip, pencil and
charcoal. The pad is pressure-sensitive and has facilities that even allow
you to choose the grain of the surface you are working on. It is ideal for
those with traditional drawing or painting skills, with the advantage that

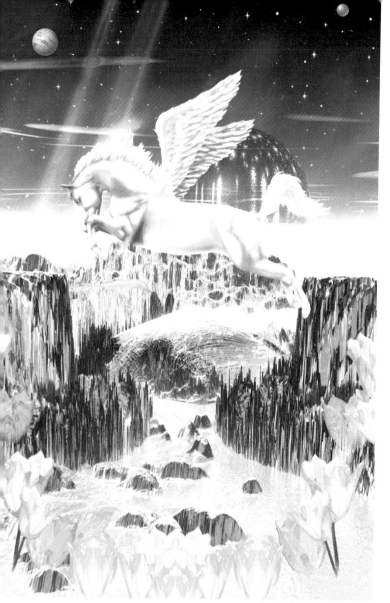

Not an enormously successful poster, but satisfying for the artist, who wanted to try a strong, simple and purely geometric design.

◀ **Winter Flight** 1994
Poster: Cartel/Athena
Programs: KPT Bryce, Photoshop

Ziewe's first composition using the KPT Bryce landscape program. It took 200 hours to render the background on the Macintosh Quadra 900.

one can experiment and erase any mistakes far more easily. It is also possible to change media without all the usual hassle of cleaning your brushes and hands, or waiting while the surface dries. Many artists enjoy using the tablet because the results can also be blended with photography. A computer mouse can be used instead, but compared to the graphics tablet, it is like drawing with a brick.

Another useful and interesting tool is a Morph program, which allows different images to be merged together, though there are limits. Merging several different faces is easy, because the features are basically similar; even merging a face with the front of a car is sometimes possible. However, merging two totally dissimilar objects requires the creation of intermediate stages or some degree of contrived matching. The results of morphing are often surprising, sometimes pleasant but more often ludicrous, as when Ziewe tried to morph an ape with an ostrich. He has also used the Morph program to produce quasi-animation of his creations for rave light shows, producing a curious stroboscopic effect that in some ways is even better than straightforward animation.

Although Ziewe has been prolific in his published work over the past few years, it is only part of his output:

'Many of these pictures are the result of play and experiment. You have to experiment sometimes to trigger new ideas, but the majority never see the light of day.'

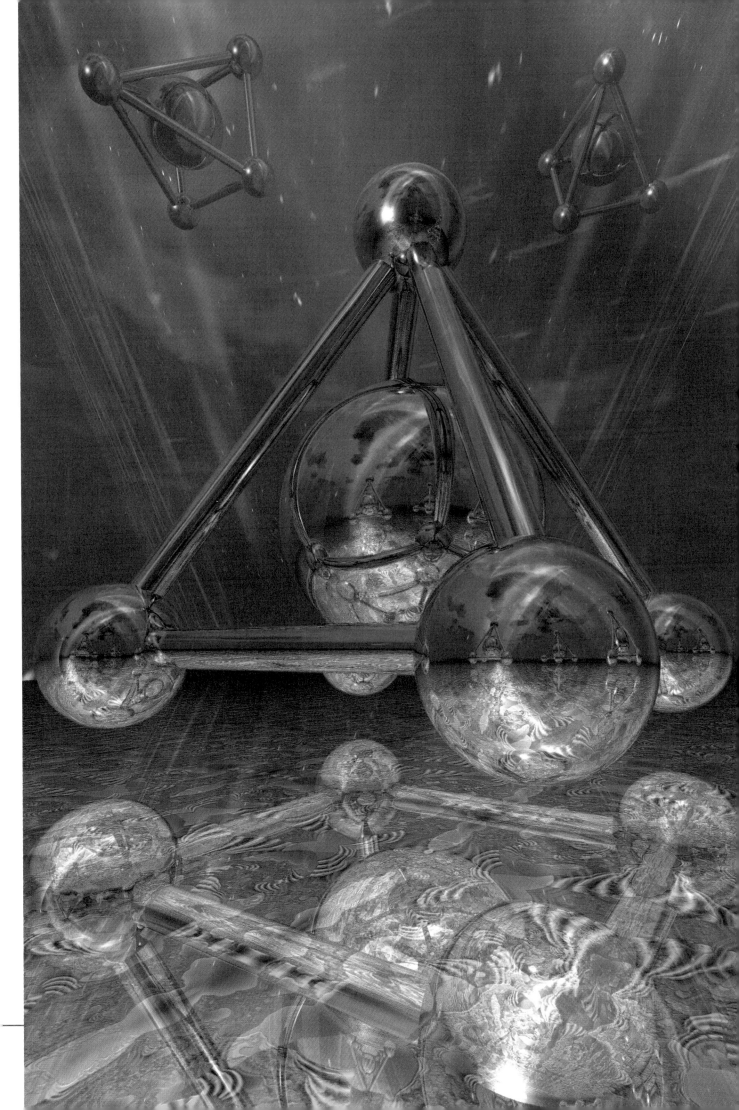

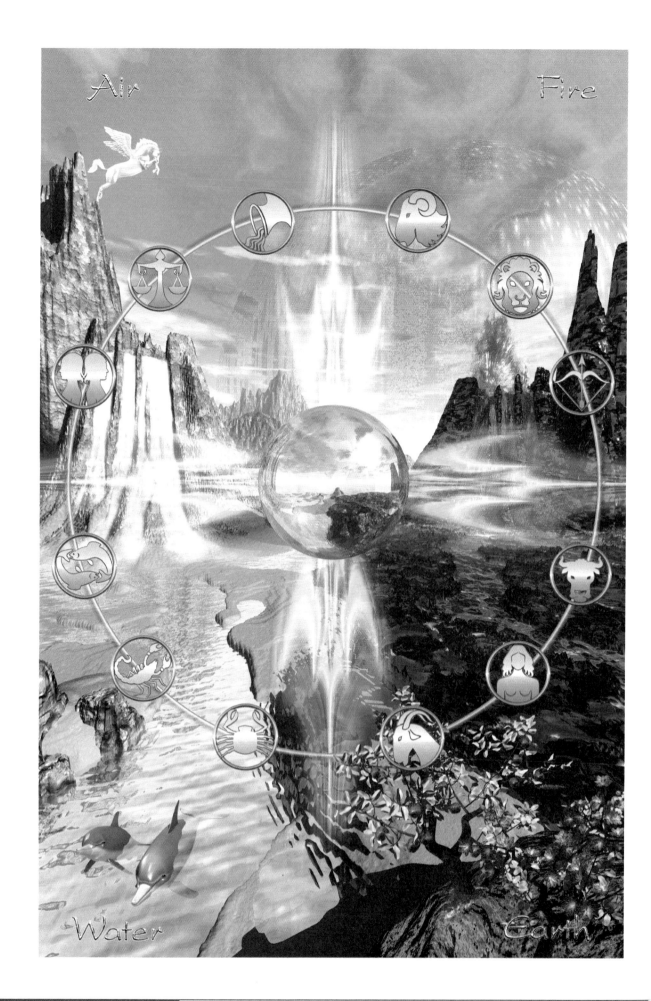

Air

Fire

Water

Earth

'Every week or so I collect all the bits and pieces I've generated to see if anything works. I save the good stuff but the rest gets binned; all that's wasted is electricity. My computers stay on most of the time because they're always at work rendering something or other that might become a picture.

'I prefer to experiment late at night because then I can switch off and relax. I've done all my chores for the day and there's no distraction from the phone. It's almost like dreaming. Often a tiny detail will trigger my imagination, a figure will appear in some part of a landscape and a picture forms. You have to let the pictures themselves guide you. Computers have their own way of operating which leads to different results from traditional painting.'

What does his wife Julia think of the time Jürgen spends exploring new worlds on the computer?

'Before we got married I lived in a studio with no furniture, just paintings, a kettle, and the odd box to sit on. It must have given Julia some idea of what to expect. She's a wonderful lady – I lock myself away for hours on end, first with painting and now with the computer, but she has been 100 per cent supportive.'

They met when, in his youth, Ziewe took a backpacking holiday to the west of England. It should have been no more than a holiday romance because, although they tried to keep in touch, the letters gradually dwindled. However, four years later she sent a postcard to say she was visiting Germany and would Jürgen like to meet up again? That he received it was a triumph of synchronicity because the student hostel in Hamburg to which she sent the card was in the process of being demolished. On a whim he went to see how the demolition was going and, on a further whim, decided to check his old mailbox in the tottering building. As the card had been there for less than a week it still remains a mystery as to why the postman delivered it.

◀ **The Four Elements** 1995
Poster: Cartel/Athena
Programs: KPT Fractal Explorer,
KPT Bryce, Strata Studio Pro, Photoshop

While Ziewe was photographing some white horses in a field near his home, one fortuitously went a bit wild and has since been the model for several unicorns and depictions of Pegasus, including the one here.

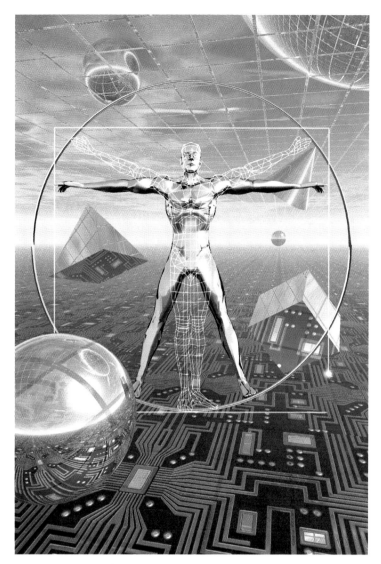

▲ **Future Dimensions of Man** 1995
Poster: Cartel/Athena
Programs: Adobe Illustrator, KPT Bryce,
Strata Studio Pro, Photoshop

A picture which sums up Ziewe's view of computers in art and how they may perhaps liberate the imagination as much as the light of reason did during the Renaissance, here represented by the echo of Leonardo's famous diagram. The sphere, pyramid and cube are not only the classical building blocks of form, which art students once had to study laboriously; they also have a symbolic significance: the sphere represents spirituality and is associated with the colour blue; the pyramid represents thought or mind and is associated with yellow; the cube represents emotionality or earthiness and is associated with red.

Travels to Other Worlds

The way Ziewe works on the computer is very similar to how he used to paint, no matter how different the results seem. He lays down an idea, image or pattern and waits for his imagination to respond to it. Also, the same rules of composition still apply.

Overall composition of a picture can be quite fast work on the computer, once the main elements such as landscape and human figures have been generated. Balancing areas of colour, changing the position and intensity of the light source and so on are all very rapid operations. Often in 3D programs it takes only a few seconds to tell if an idea is going to work or not, at which point the image on the screen is no more than a patchwork of large, coloured squares.

Choosing an angle of view on a scene and the focal length, or degree of 'fisheye' effect, in the virtual camera can also be quick, although the scene will only be presented in a very sketchy, wire-frame form as you move through it. To get a clearer picture of what you are looking at takes longer, as the computer has to work through the scene line by line, steadily subdividing the coloured squares into smaller and smaller pixels until the fine detail emerges.

The Visit 1996 ▶
Poster: Cartel/Athena
Programs: Strata Studio Pro, KPT Bryce, Photoshop

The first version of this showed the head against the background of an alien cityscape, but it was decided that this missed the point of the prevailing interest in alien abductions, which is their impact on Earth dwellers rather than curiosity about where aliens might come from. The second version was loosely inspired by a scene in Close Encounters of the Third Kind. The Alien has no mouth to stress that there is no normal means of communication with such creatures. Also, in the course of having learned to flit across light-years via other dimensions they have learned to nourish themselves directly from cosmic matter, and being also telepathic the need for mouths has withered away.

Flying Saucer 1996 ▶
Detail of **The Visit**
(opposite)
Program: Strata Studio Pro

The spiked light adds an element of menace to the prospect of being abducted.

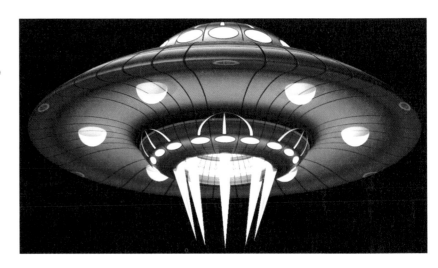

The Visit 1996 ▶
Sketches

Sketches showing how a holiday snap taken in the Norfolk Broads became the background for this poster concept. Photoshop was used to turn day into night and the stars were added from KPT Bryce.

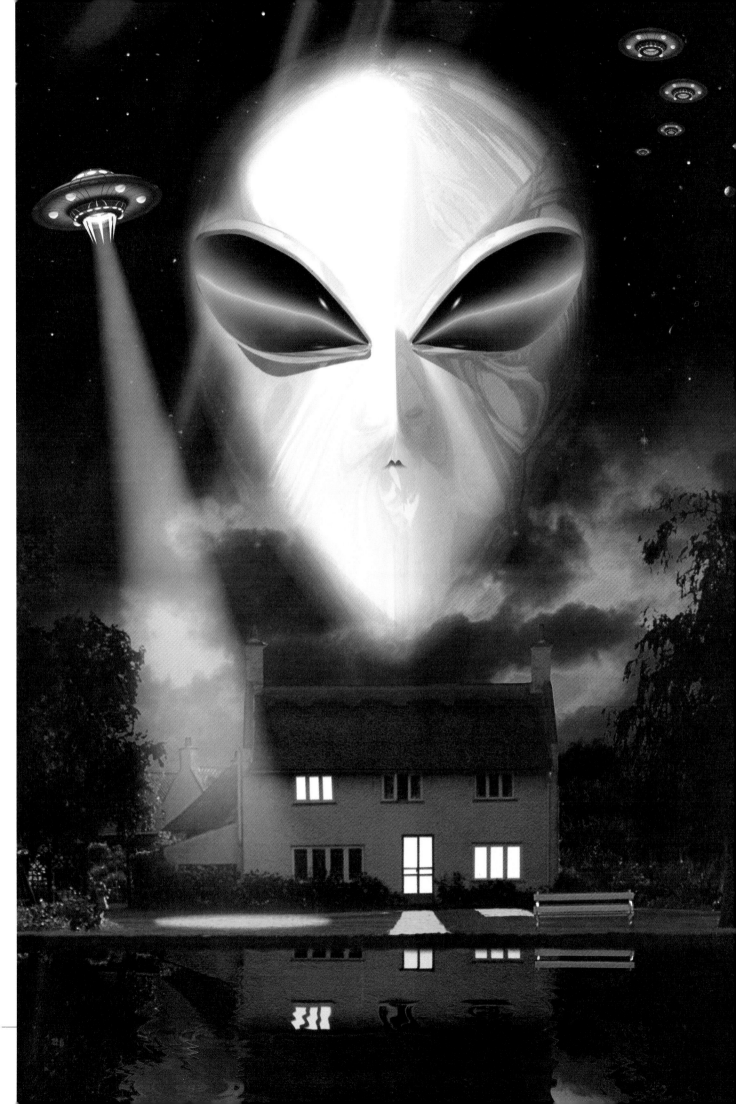

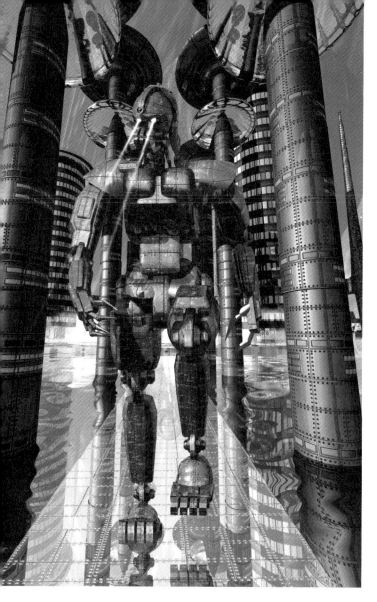

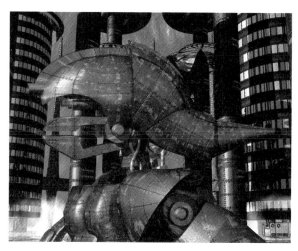

▲ Detail of **Cyborg Warrior** (left) 1995

◀ **Cyborg Warrior** 1995
Private work
Programs: KPT Bryce,
Strata Studio Pro, Photoshop

*This picture has been the basis of several
different designs, including a poster by
Scandecor, which used the background as the
setting for a rampant robot designed by
another artist. The texture of this cyborg
warrior was achieved by mapping photographs
of rusty iron onto the 3D model.*

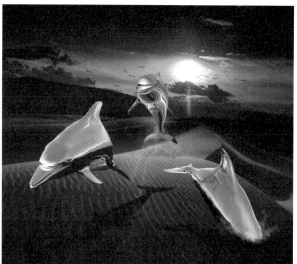

◀ **Desert Dolphin** 1996
Advertisement: Kodak
(Agents Gower & Vince)
Programs: Strata Studio Pro, Photoshop

*One of a set of images commissioned for
an advertising campaign entitled* The New
Golden Age of Film. *The background was
supplied by the agents.*

◀ **The New Golden
Age of Film** 1996
Advertisement: Kodak
(Agents Gower & Vince)
Programs: KPT Bryce,
Photoshop

*The background of Cyborg
Warrior came in useful again for
this picture, with movie film cans
inserted into the architecture.*

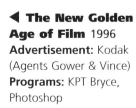

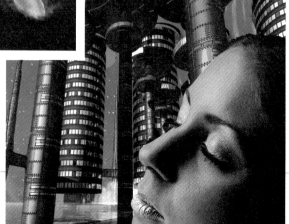

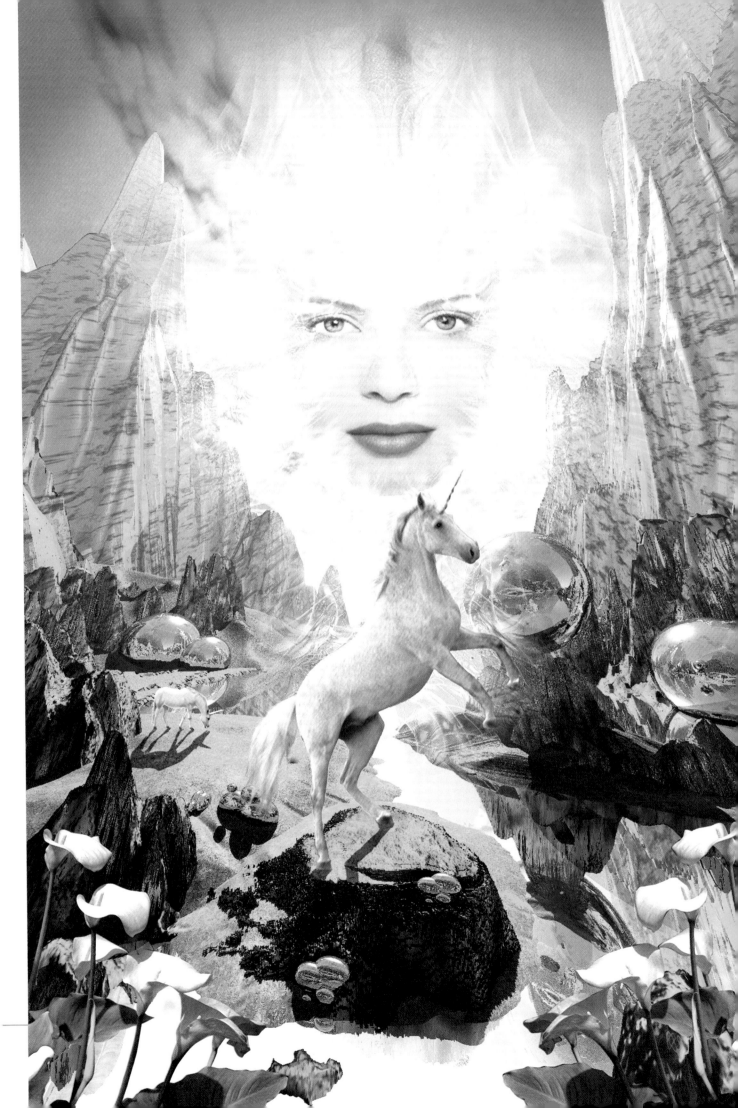

◀ Previous Page
**The Princess and
the Unicorn** 1995
Poster: Unpublished
Programs: KPT Fractal
Explorer, KPT Bryce,
Morph, Photoshop

Zodiac 1995 ▶
Poster: Verkerke
Programs: KPT Fractal Explorer,
KPT Gradient Designer,
KPT Bryce, Adobe Illustrator,
Strata Studio Pro, Photoshop

*The Virgo symbol was derived from
an Eric Gill design from the 1930s.*

Virtual Reality

Many of Ziewe's landscapes have been created purely for the pleasure
of doing so, for the fascination of making fantasy real in a way never
before possible. Jürgen's aim is to create things and places that could
only have reality in a different universe or plane of consciousness.

Practical applications often only arise later, when either a commission
comes along that calls for an idea he has already had, or when
imagination suggests a way it can be taken further. Many pictures in
this section are taken from *Journey of a Virtual Traveller*, a
computerized graphic novel on which Ziewe is working. This began
with the creation of a fantasy environment into which characters and
story were later introduced.

The world of the Virtual Traveller is stored on several different files
combined by means of a map showing how the parts fit together. In

Infinity 1995 ▶
Poster: Unpublished
Programs: Adobe Illustrator,
KPT Bryce, Photoshop

*The central motif consists of a single
continuous bar which seemed to Jürgen
to be an apt symbol of infinity.*

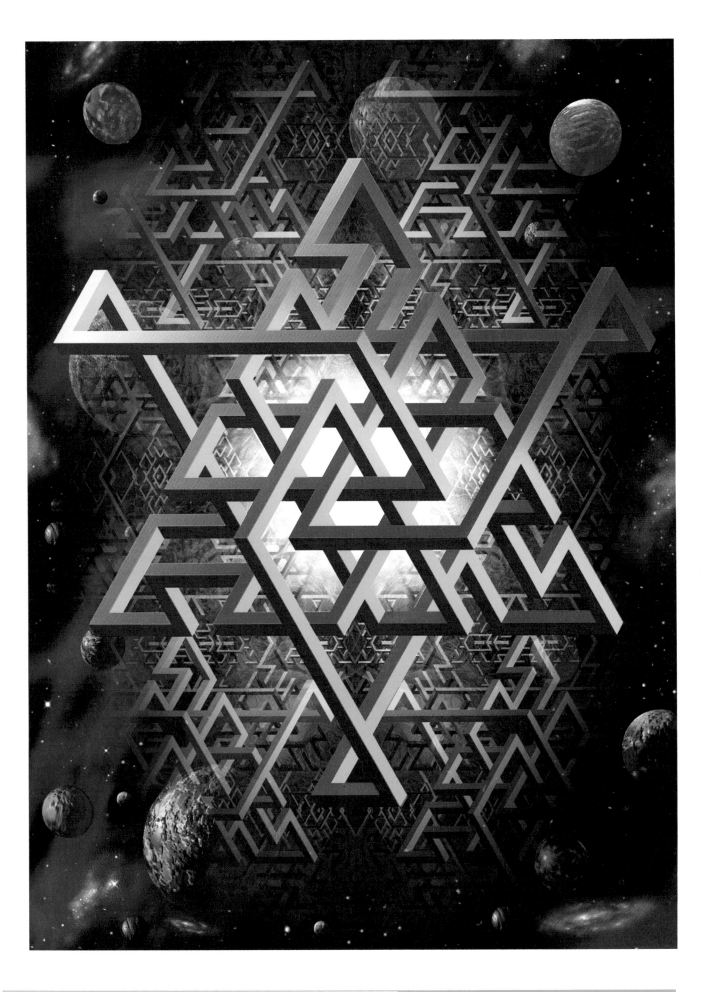

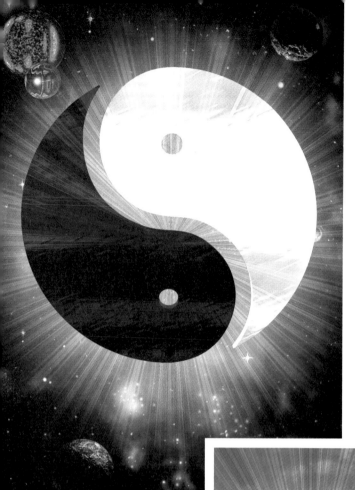

◀ Yin Yang II 1994
Card: Inner Eye Publishing
Programs: KPT Gradient Designer,
KPT Bryce, Strata Studio Pro,
Photoshop

Ziewe's own preferred version of this design.

Prism of Life 1994 ▶
Poster: Cartel/Athena
Programs: KPT Fractal Explorer,
KPT Bryce, Strata Studio Pro,
Photoshop

A concept suggested by the publisher.

Yin Yang 1994 ▶
Poster: Verkerke
Programs: KPT Gradient
Designer, Illustrator, Strata
Studio Pro, Photoshop

theory the files could be combined to create one vast virtual world, but to do this without losing the resolution is beyond the memory capacity of Ziewe's current computers. However, by using the map for reference, one can still effectively move throughout the world with only slight delays when crossing the frontiers. The story of Virtual Traveller tells of someone taking a holiday in a virtual world that by degrees becomes uncomfortably real.

At present Jürgen can create such worlds within the computer but not explore them in real time. That is, he can zoom about in them and pick selected viewpoints, but all that is visible on the screen is a sketchy outline of the changing terrain. To get a clear view at any point, the computer must stop and work awhile to render the scene. It is a

Planet Surface 1994 ▶
Program: KPT Bryce

Detail of planet surface in
Prism of Life *(above).*

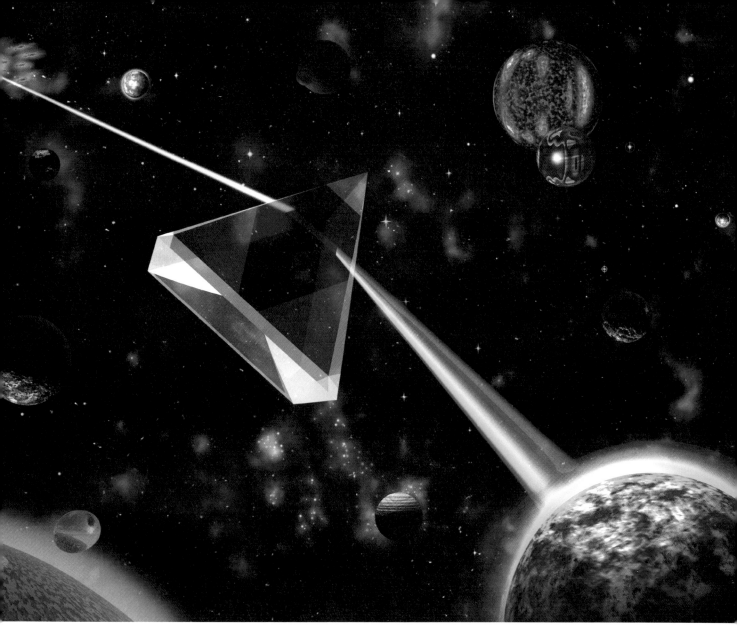

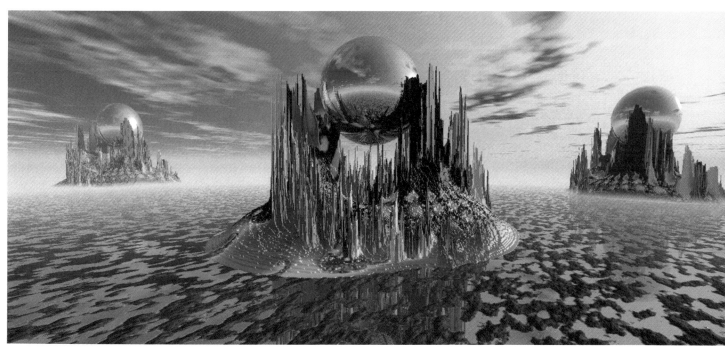

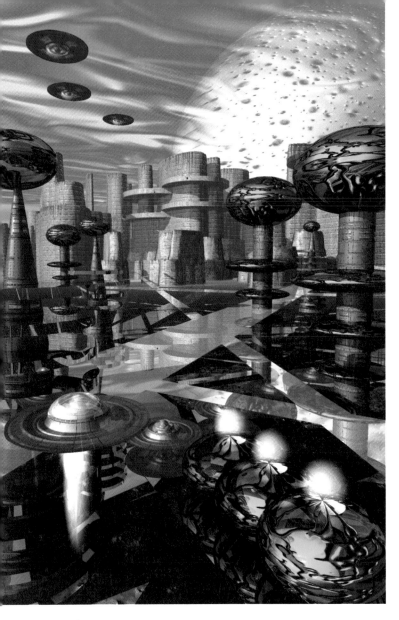

▲ Alien Cityscape 1996
Private work
Program: KPT Bryce

Fractal Universe 1996 ▶
Poster: Unpublished
Programs: KPT Bryce,
Strata Studio Pro, Photoshop

*Seeing the film of Arthur C. Clarke's 2001
was for Ziewe one of those experiences after
which the world never looks quite the same
again, particularly the sequence of the
landing on Jupiter. The impression it made is
one he aims to recapture in scenes like this,
with a combination of wonder and infinite
possibilities. He still finds the film as fresh as
when he first saw it in about 1970.
The fractal designs for these formations were
generated with Kai's Power Tools, converted
into a grayscale map and imported into a KPT
Bryce landscape program to create a terrain
of floating galaxies. Some planets, the
spaceship and space stations were created
with Strata Studio Pro.*

▼ Space Station 1996
Detail of **Fractal
Universe** (opposite).
Programs: KPT Bryce,
Strata Studio Pro, Photoshop

bit like walking through a snowstorm which magically switches off
whenever you stop for a tea break. In theory it is possible to animate
any chosen path through this world on Ziewe's current equipment and
software by stopping enough times, but at the twenty-five or so frames
per second required, it would take a vast amount of processing time. A
90-minute film, for example, would take seven and a half years simply
to process.

This is likely to change dramatically in the near future, however.
Metatools are planning to release a new version of Bryce allowing for
animation, possibly running on a multiprocessor Mac. This will cut the
time significantly and bring us a large step closer to the day when an

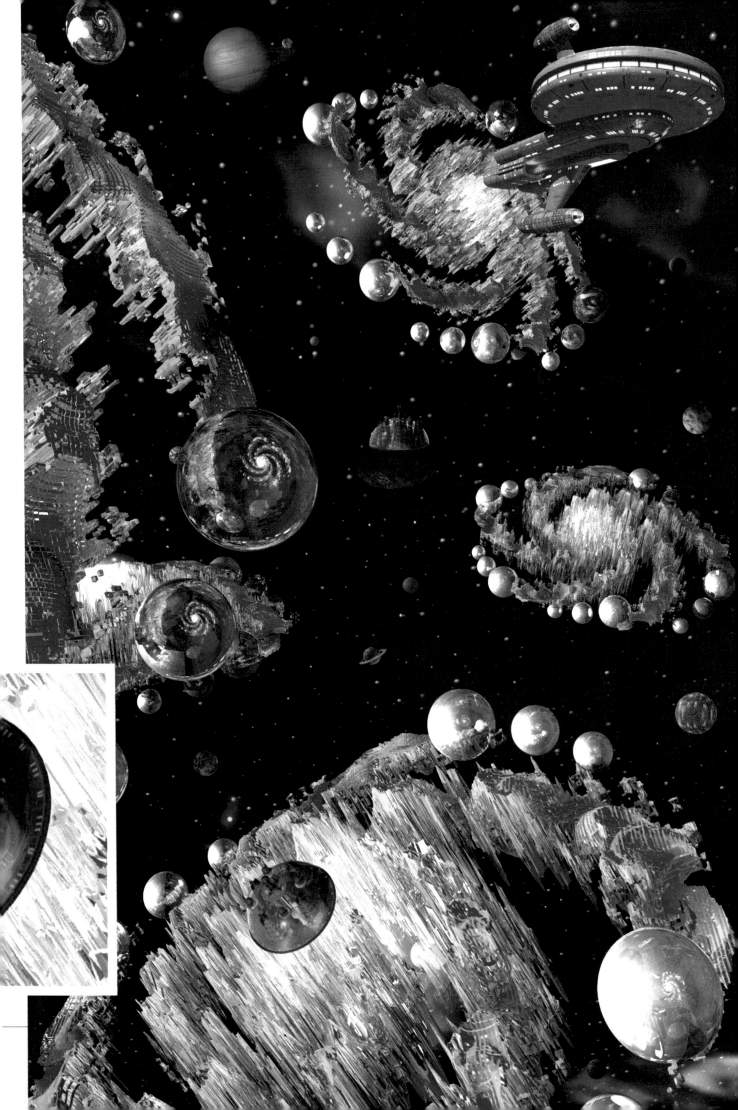

◀ Sketch from *Journal of a Virtual Traveller* 1995
Programs: KPT Bryce, Strata Studio Pro, Photoshop

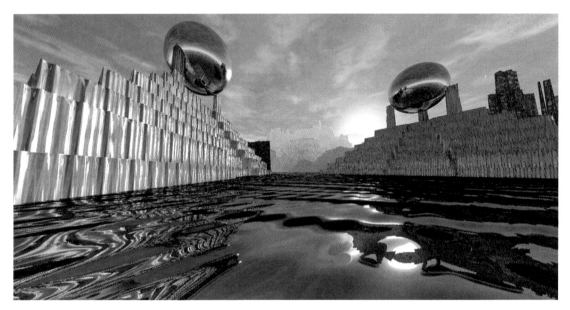

▲ Sketch from *Journal of a Virtual Traveller* 1995
Programs: KPT Bryce, Strata Studio Pro, Photoshop

artist will be able to sit down at a computer and single-handedly create an animated feature film, much as a writer produces a novel. At present, a completely computer-animated feature film like Disney's *Toy Story* requires a bank of Silicon Graphics computers and an army of animators, directors, et cetera, as can be seen by the credit list at the end, not to mention a Hollywood-style budget to match.

Animating a preset journey through a virtual world is one thing, moving completely freely around in them is another. One can do this to an extent already at Virtual Reality entertainment centres, but it takes enormous computing power to generate what are really quite primitive environments.

Sketch from *Journal of a Virtual Traveller* 1995 ▶
Programs: Fractal Design Poser, KPT Bryce, Strata Studio Pro, Photoshop

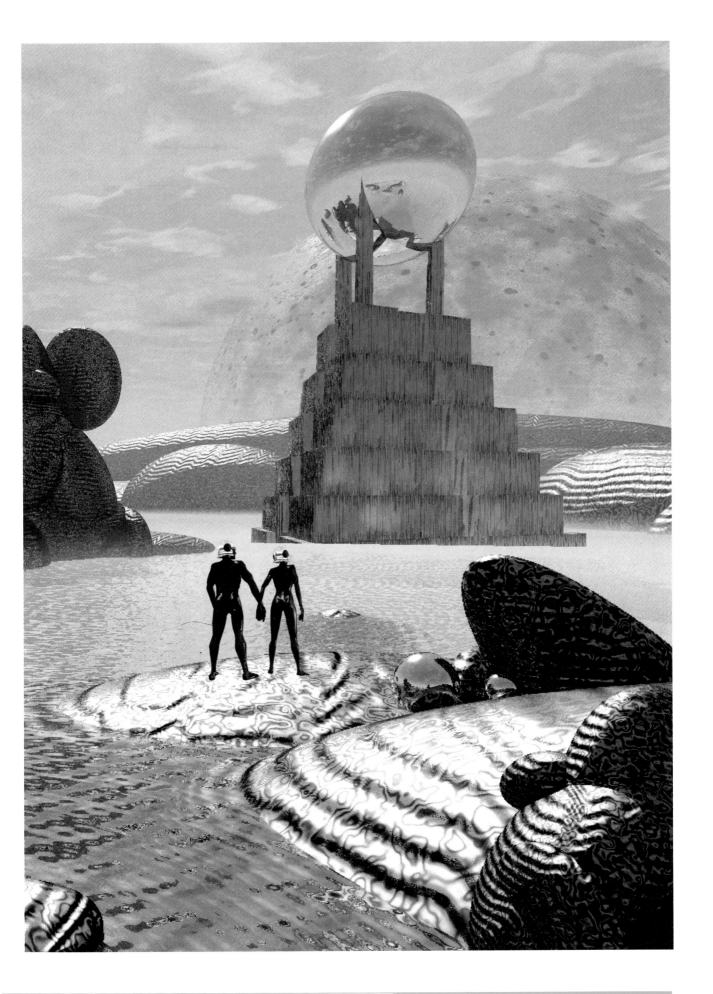

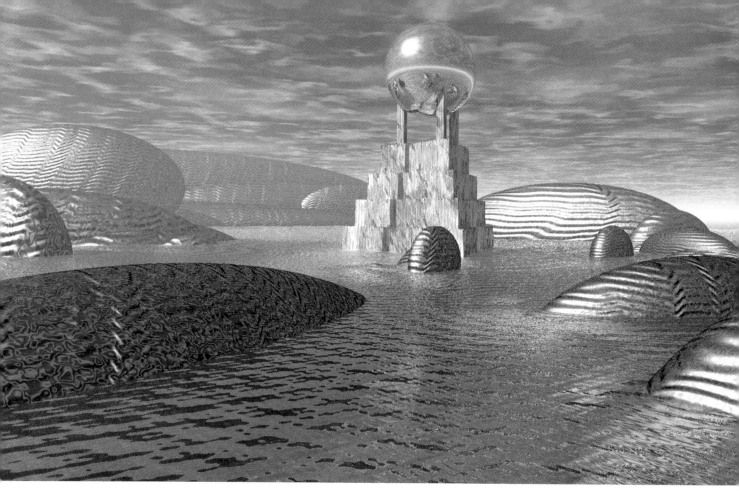

▲ Sketch from *Journal of a Virtual Traveller* 1995
Program: KPT Bryce

▼ Sketch from *Journal of a Virtual Traveller* 1995
Program: KPT Bryce

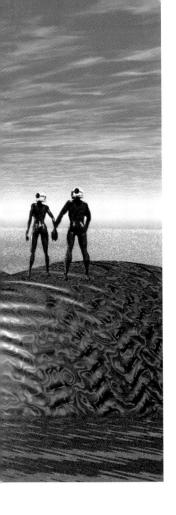

To be able to do it in a world like that of the Virtual Traveller would at present take more humming processors than Jürgen could ever imagine. But again the possibility is not very far over the horizon, as the power of computers has consistently doubled every eighteen months for the past thirty years or more and shows no sign of slowing.

The prospect of anyone being able to produce animated films single-handedly is one that many people view with horror, along with other aspects of Virtual Reality such as its wider impact on society, but Ziewe himself is optimistic:

'Virtual Reality could have horrendous implications, but there is also a tremendous potential for creativity on all levels. In a few years I can really imagine that artists will be able to create pictures that are no longer separated from the viewer. To an extent you get this already with installations and sculpture, especially from someone like Christo – the artist who specializes in wrapping whole mountains and buildings, such as the Reichstag in Berlin – but until now, artists have not been able to create whole environments in which viewers can truly immerse themselves.

◄ **View Across Water** 1995
Sketch from *Journal of a Virtual Traveller*
Programs: Fractal Design Poser, KPT Bryce, Strata Studio Pro, Photoshop

▼ **Sketch from** *Journal of a Virtual Traveller* 1995
Program: KPT Bryce

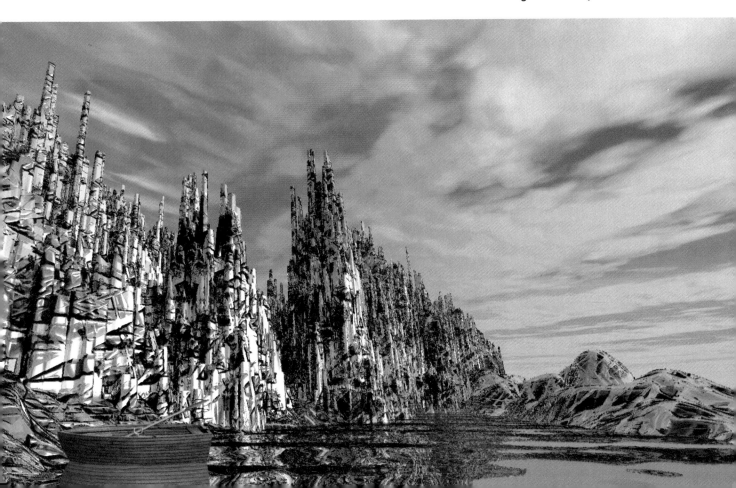

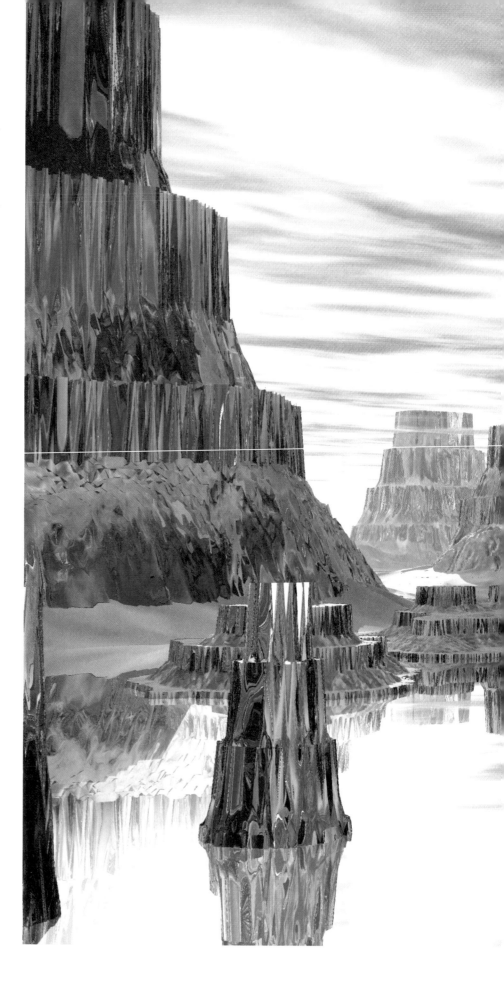

Vacation in Cyberworld 1996 ▶
Private Work
Programs: Fractal Design Poser,
KPT Bryce, Strata Studio Pro,
Photoshop

*For a step-by-step guide to how
this scene was created, see the following
pages.*

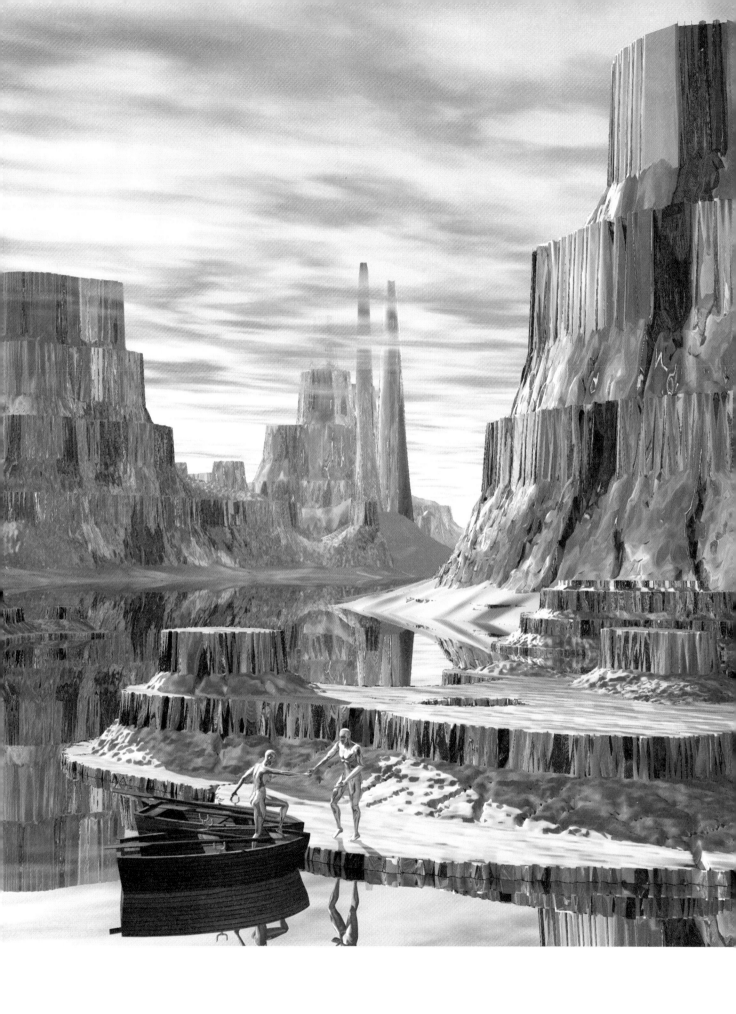

How *Vacation in Cyberworld* was Created

1 'The terrain map was generated in Photoshop, then imported into Bryce where it was copied and pasted into the terrain modeller. The rocky outcrops were stepped and carved up a bit before "erosion" was applied. As in nature, this program eats away at the structures similarly to wind or rain.'

2 'Composition was taken care of at this stage by a careful choice of camera angle. Selecting the best view, a wire-frame impression of the composition was achieved. Unlike a real photographer, you can move mountains around at this point to suit your composition. The focal length of the computer's camera was chosen for the most dramatic effect, with a range available from the equivalent of telephoto to wide angle lenses. Then I experimented with the surface textures. Just using the random pattern generator in the program can produce surprising textures.'

3 'The light source was positioned to highlight the right areas of the picture. This has to be taken into account in the composition, along with colour and shape. A few seconds of rough rendering will give me a first indication of the picture. It doesn't have to go much further. I squint my eyes and if I am not happy with the distribution of colour patches, I go back into wire-frame mode, move some terrain around, and change the atmosphere or camera position.'

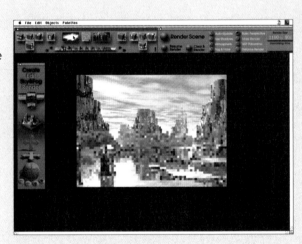

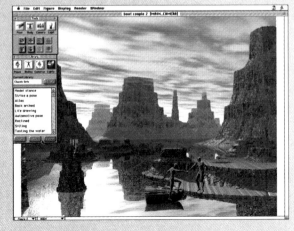

4 'For the boat texture, I photographed my neighbour's fence and another piece of old wood was used for the grain of the boat seats. The boat was modelled first in Strata Studio, montaged onto the rendered scene in Photoshop and imported as a background into Poser so the figures could be positioned accurately. I then saved the figures as DXF files and imported them into Strata Studio Pro.'

5 'I then smoothed the figures with a 90° smoothing angle and placed them into the right position. The metallic texture for the figures was also selected. For the water reflection a flat mirror-like surface was created. To give it a wavy effect you can also apply an appropriate bump map. Using different views ensures that the figures are positioned accurately. The light and atmosphere of the Bryce image was emulated by adding coloured gels to the light sources.'

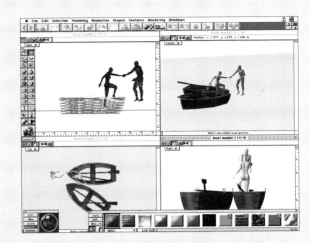

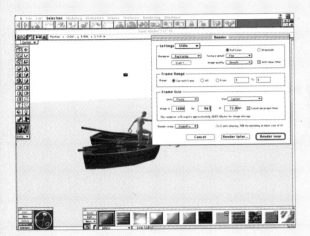

6 'Once the scene was completed, I selected raytrace rendering and pulled the camera marque across the section I wanted to render. It has to be made large enough to allow for more retouching in Photoshop.'

7 'Once you have selected the right view, it is a good idea to save it as a window which you can call up at any time to make adjustments to the perspective. The rough render gives a good indication of whether to proceed or make further adjustments to the light or viewpoint. You can also create a camera viewpoint which allows you greater flexibility over the focal length. After rendering, the image is saved as a PICT file.'

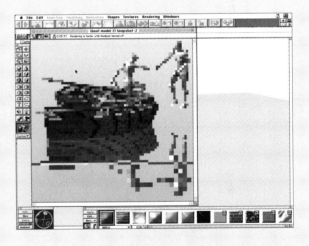

8 'The rendered file was then opened in Photoshop. Cutting the image out was easily achieved with the magic wand tool. To do this the tolerance was set reasonably low. Retouching was also done at this stage.
'The male figure was rendered twice; once for the reflection in the water and once standing on a green floor in order to reflect the green colour of the Bryce landscape into the figure just for extra realism. The Bryce picture was opened and the two elements montaged together to create the final picture.'

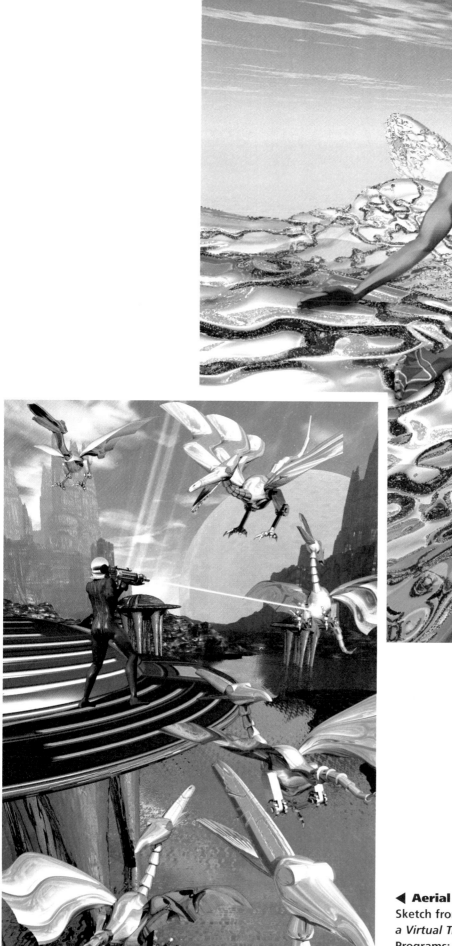

▲ **Cyber Bathing** 1995
Sketch from *Journal of
a Virtual Traveller*
Programs: Fractal Design Poser,
KPT Bryce, Strata Studio Pro,
Photoshop

◀ **Aerial Assault** 1995
Sketch from *Journal of
a Virtual Traveller*
Programs: Fractal Design Poser,
KPT Bryce, Strata Studio Pro,
Photoshop

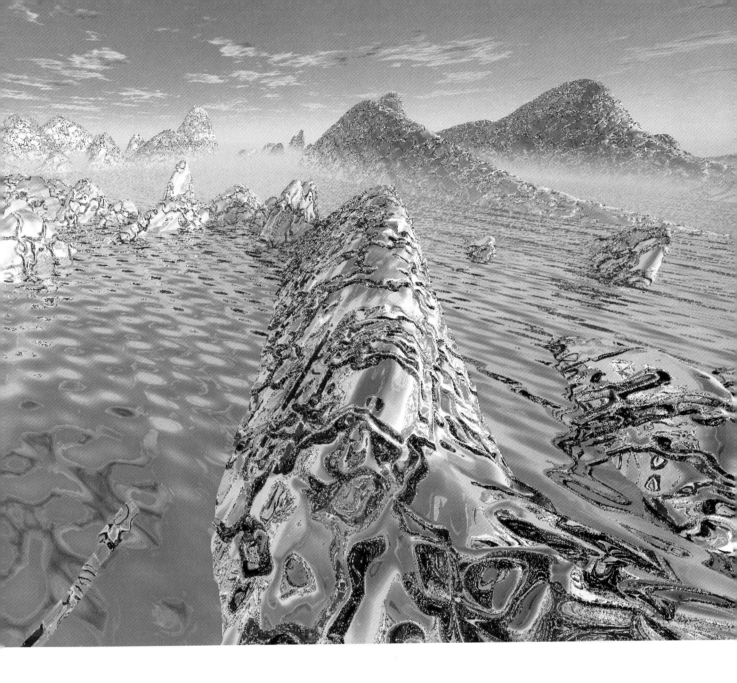

With Virtual Reality it becomes possible to create whole dreamlike landscapes of different realities which people can enter with full consciousness. Most of what I have created could be used in this way. I refer to these pictures as "blueprints to visual immersion" because they give glimpses of what it will soon be possible to experience in a whole new way.'

What he has in mind are not purely passive environments either, that one can only explore as a kind of disembodied eye. The idea is that visitors should be able to interact with their environment.

At the first conference on Virtual Reality which he attended, at a time when the concept was just starting to filter through to popular consciousness, he found an enormous pessimism about the likely social effects of the new technology. Many people assumed it would lead to further social fragmentation and the isolation of individuals, locked in their bedrooms with their computers and headsets. In practice that has not really happened, at least among the young. In the rave culture almost the opposite seems to be the case, to an extent that in itself seems to alarm many people.

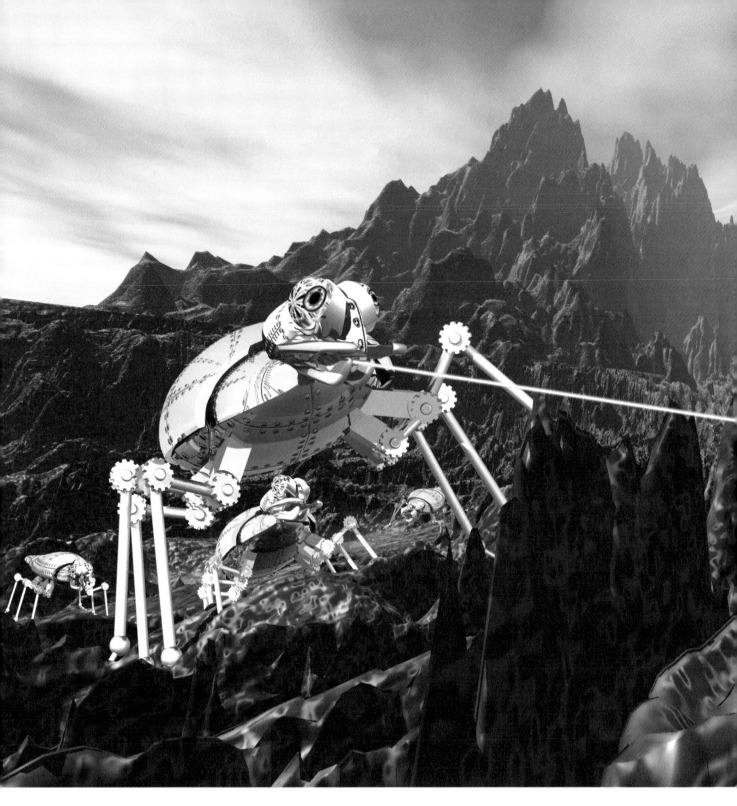

▲ Attack of the Cyber Bugs 1995
Sketch from *Journal of
a Virtual Traveller*
Programs: Fractal Design Poser, KPT
Bryce, Strata Studio Pro, Photoshop

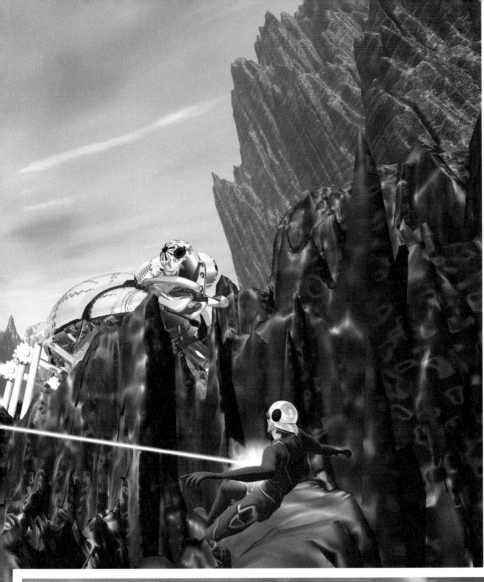

▼ Ruin 1995
**Sketch from *Journal
of a Virtual Traveller***
Programs: KPT Bryce,
Strata Studio Pro, Photoshop

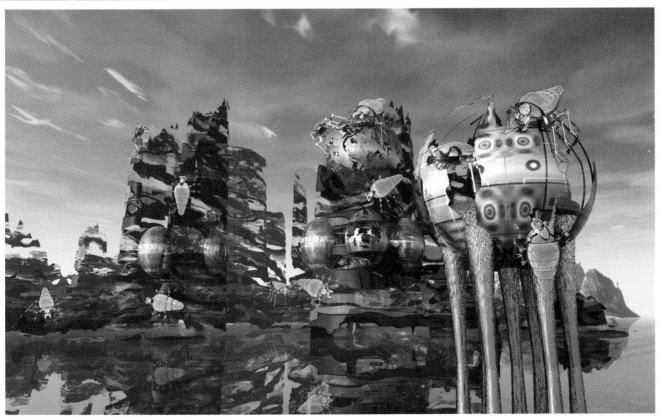

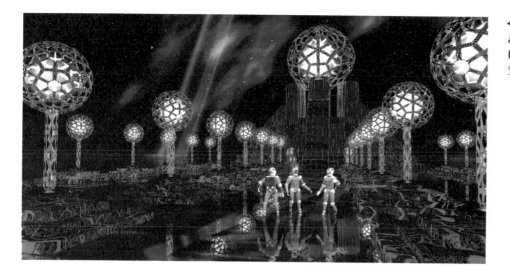

◀ **Sketch from** *Journal of a Virtual Traveller* 1995
Programs: KPT Bryce, Strata Studio Pro, Photoshop

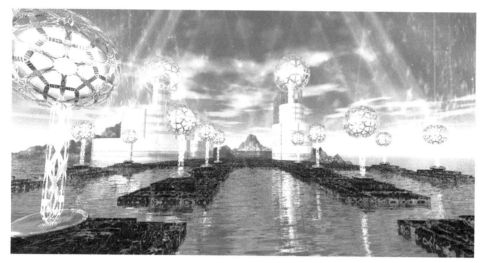

◀ **Sketch from** *Journal of a Virtual Traveller* 1995
Programs: KPT Bryce, Strata Studio Pro, Photoshop

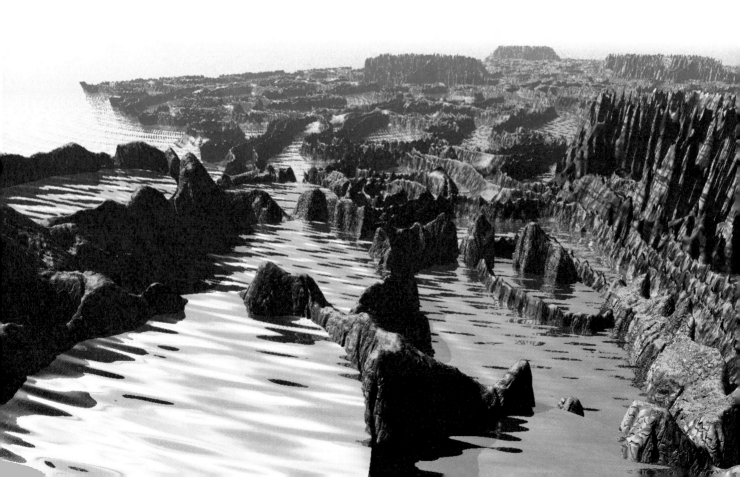

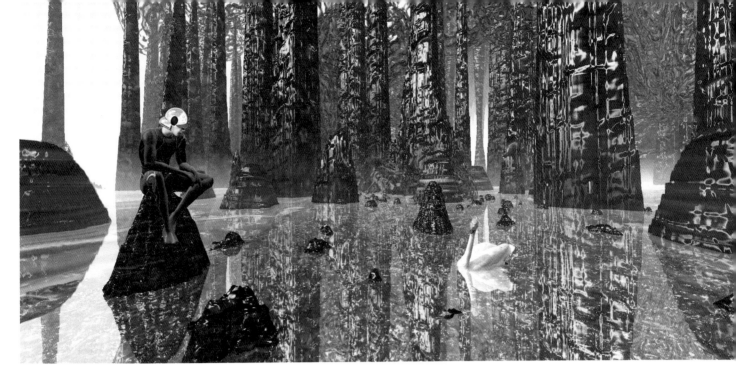

▲ Swan 1995
Sketch from *Journal
of a Virtual Traveller*
Programs: Fractal Design
Poser, KPT Bryce, Strata
Studio Pro, Photoshop

◀ Water Maze
1995
Sketch from *Journal
of a Virtual Traveller*
Program: KPT Bryce

Ziewe's virtual landscapes not only exist in three dimensions but they can also have changing weather of mist, rain or sunshine, and day or night. Being three-dimensional, it is a relatively simple matter to obtain paired stereoscopic views of them, which was the idea behind a set of cards Ziewe published under the title 'Virtual Reality Worlds'. The front of each card has a large image of the scene, below which is a pair of stereoscopic views (like those on pages 74 and 75). They were created as a kind of alternative to the 'Magic Eye' pictures, which are wasted on Jürgen as he is among those who cannot see them. Not everyone can see these images properly either, but at least you can tell what you are missing. However, to some people it comes quite easily, and often to those who are also blind to 'Magic Eye' pictures. The trick, Ziewe says, is this:

'Concentrate on the black dots above the two images. Let your eyes cross, moving the dots together until they merge into one, viewing the left dot with your right eye and the right dot with your left. Keep your eyes fixed in that position and gently move your attention onto the image, which should now appear as one picture. Even though you may still be aware of two faint images on either side, concentrate on the centre one, which will now reveal a 3D picture.'

Ziewe sees computers as just part of a larger revolution, embracing nanotechnology, the study of particles less than 1 millionth of a millimetre thick. In that field it is half-seriously being suggested that soon it will be possible to create almost anything you can think of from almost any raw material, simply by rearranging the atoms. Then everyone could have a machine no larger than a microwave, with a

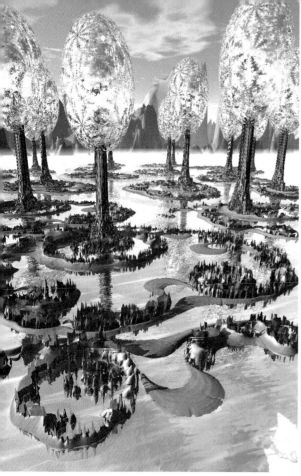 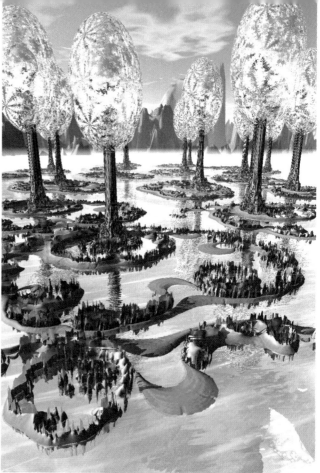

▲ **Water Park**
(Stereogram) 1996
Private work
Program: KPT Bryce

▼ **Floating Islands**
(Stereogram) 1996
Private work
Program: KPT Bryce

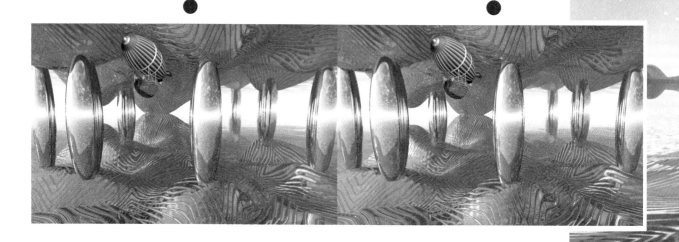

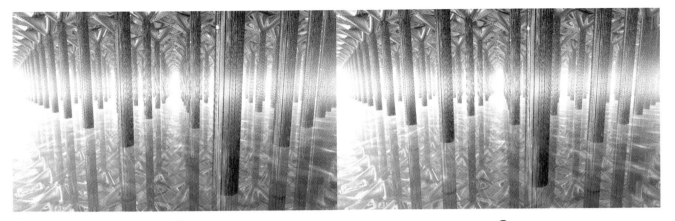

▲ **Glass Forest
(Stereogram)** 1996
Private work
Program: KPT Bryce

▼ **Floating Islands**
1996
Private work
Program: KPT Bryce

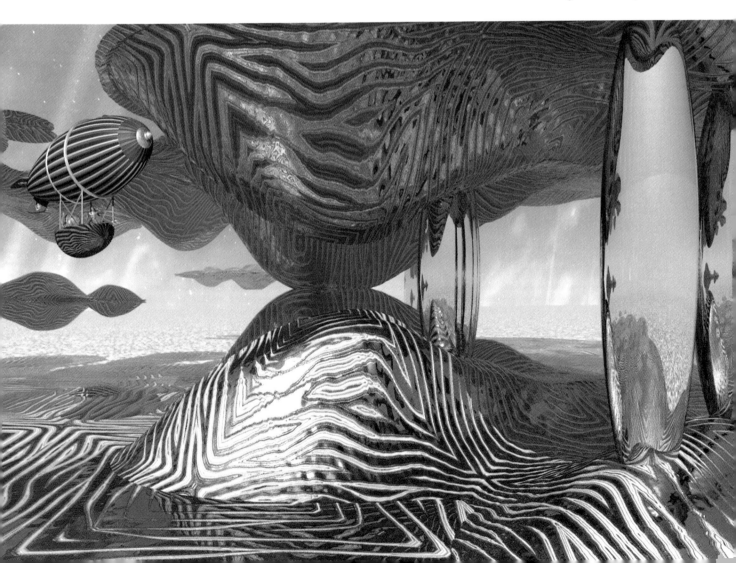

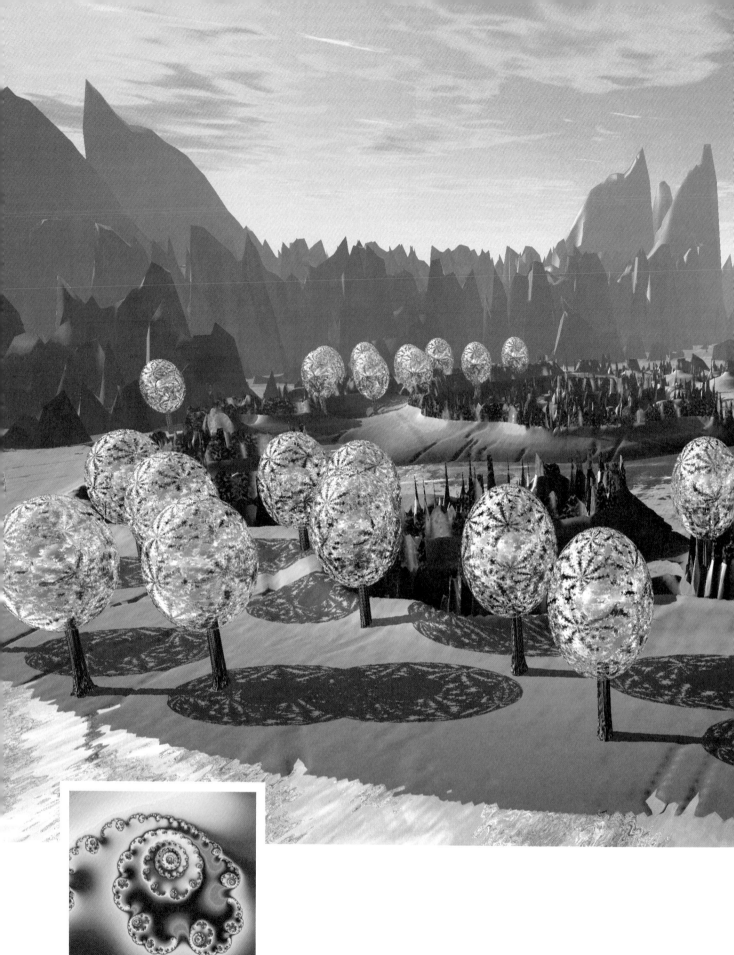

◀ Plan view of the islands in
Flight Over Fractal Archipelago (above)

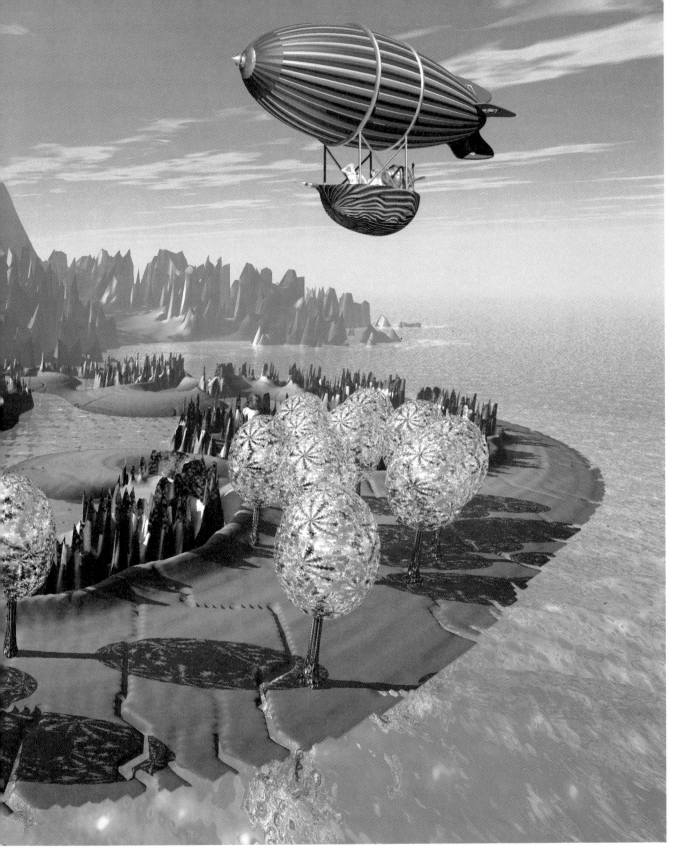

▲ **Flight Over Fractal
Archipelago** 1996
Private work
Programs: Fractal Design Poser,
KPT Fractal Explorer, KPT Bryce,
Strata Studio Pro, Photoshop

◀ **Approach** 1995
Private Work
Programs: KPT Bryce,
Strata Studio Pro, Photoshop

*An aerial view of the scene in Sanctuary
(right), taken from the pinnacle behind and
above the temple-like structure. The temple
was made in Photoshop and imported into
Bryce, which is not really designed for
creating structures like this, but can be
made to do so with a bit of ingenuity.*

▼ **Priestess** 1995
Private Work
Programs: Fractal Design Poser,
KPT Bryce, Strata Studio Pro,
Photoshop

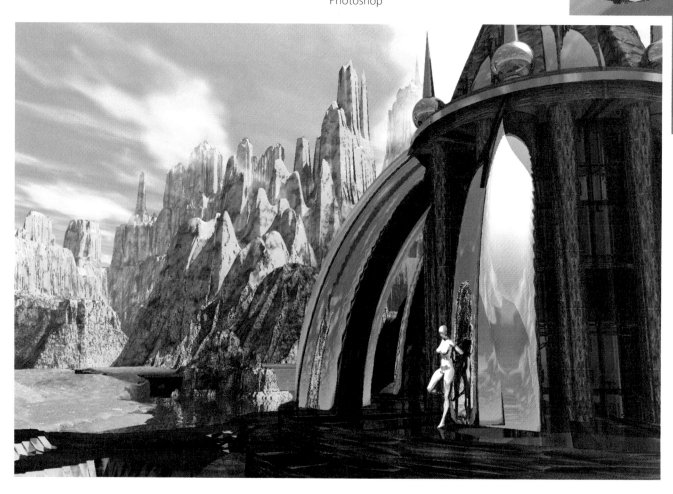

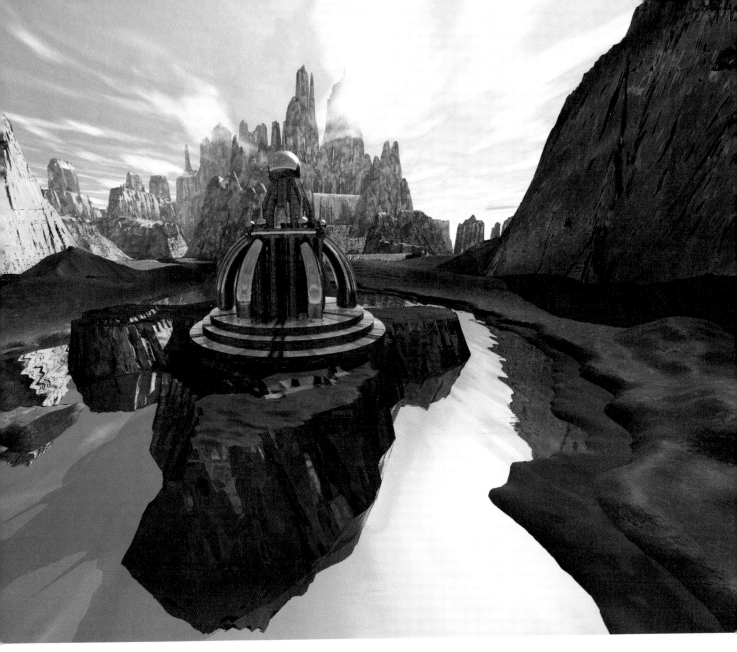

Ziewe: 'In a way, it is quite ludicrous to use a computer, which is such a technical beast, to paint scenes of unspoilt rural calm like this. But computers do allow you to experience realities which before you could only find in lucid dreams. They can give a kind of reality to subconscious things. The mood of this picture and the way the light catches reminds me a little of paintings by the nineteenth-century German artist Caspar David Friedrich, who is one of my heroes.'

keypad on which they could order up anything from a cup of coffee to a pair of shoes. Even if this only partly comes true, the borders between virtual and non-virtual reality could one day become very blurred. Ziewe sees artists of the future creating not just pictures but entire worlds with cities, parks and communities – environments limited only by people's imaginations. There could even be scary ones for those who like that kind of thing. One could choose to battle dragons and other monsters, which would be able to inflict a degree of pain through a virtual reality bodysuit. All of which, Ziewe admits, may totally screw society up because of the uncertain limits to both the pleasures and pains of such worlds. On the other hand, there might simply be an anti-technology backlash. Ziewe was surprised on a recent visit to the Trocadero Virtual Reality centre in London by how *un*-busy it was.

Cyber Trees

The attraction of creating the cyber tree pictures lay in trying to produce something that conveyed the impression of trees while using purely geometric

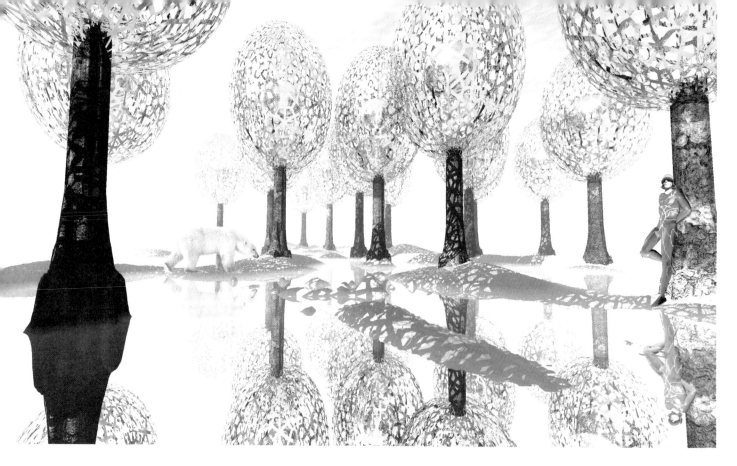

▲ **Virtual Winter** 1995
Sketch from *Journal
of a Virtual Traveller*
Programs: Fractal Design Poser,
KPT Bryce, Strata Studio Pro,
Photoshop

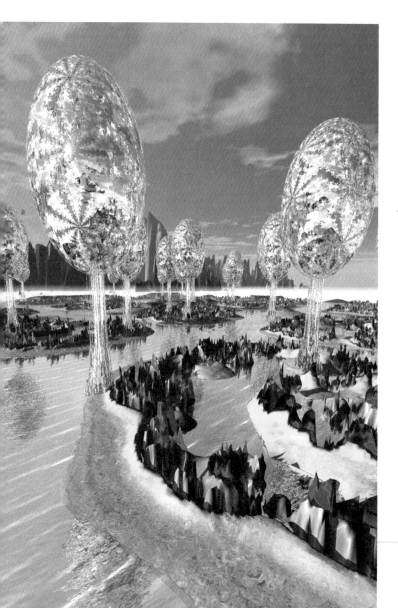

◄ **Picnic in Paradise II** 1995
Private work
Programs: Fractal Design Poser,
KPT Bryce, Strata Studio Pro,
Photoshop

Picnic in Paradise I 1995 ►
Private work
Programs: Fractal Design Poser,
KPT Bryce, Strata Studio Pro,
Photoshop

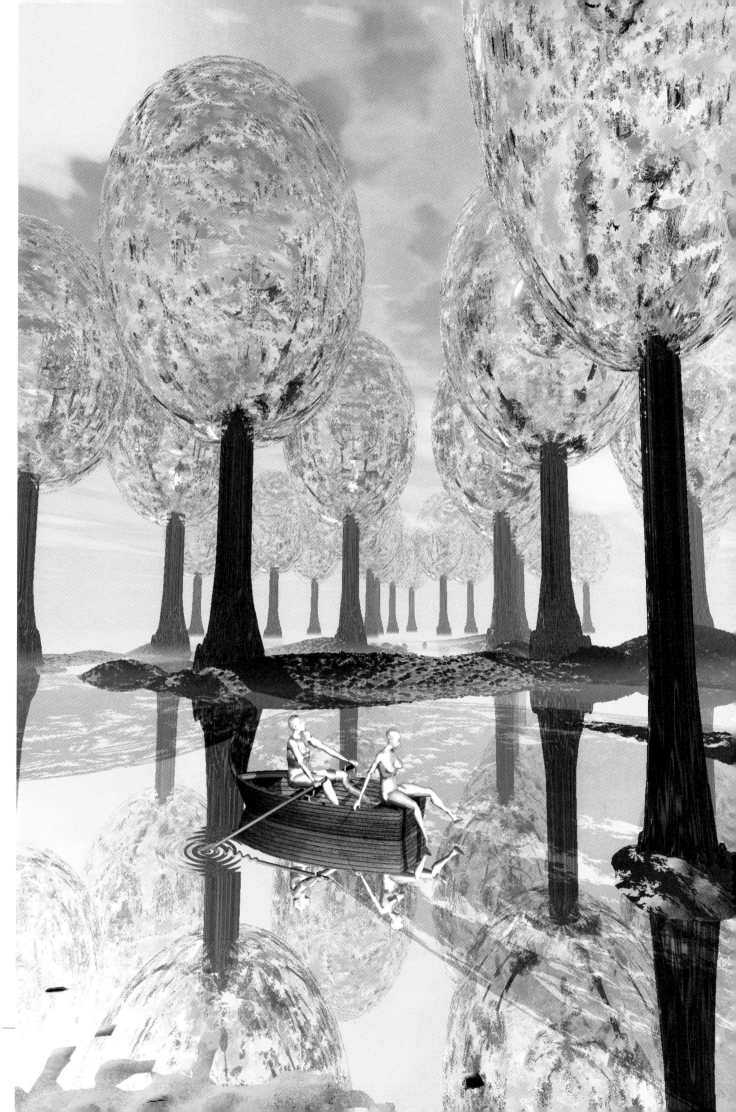

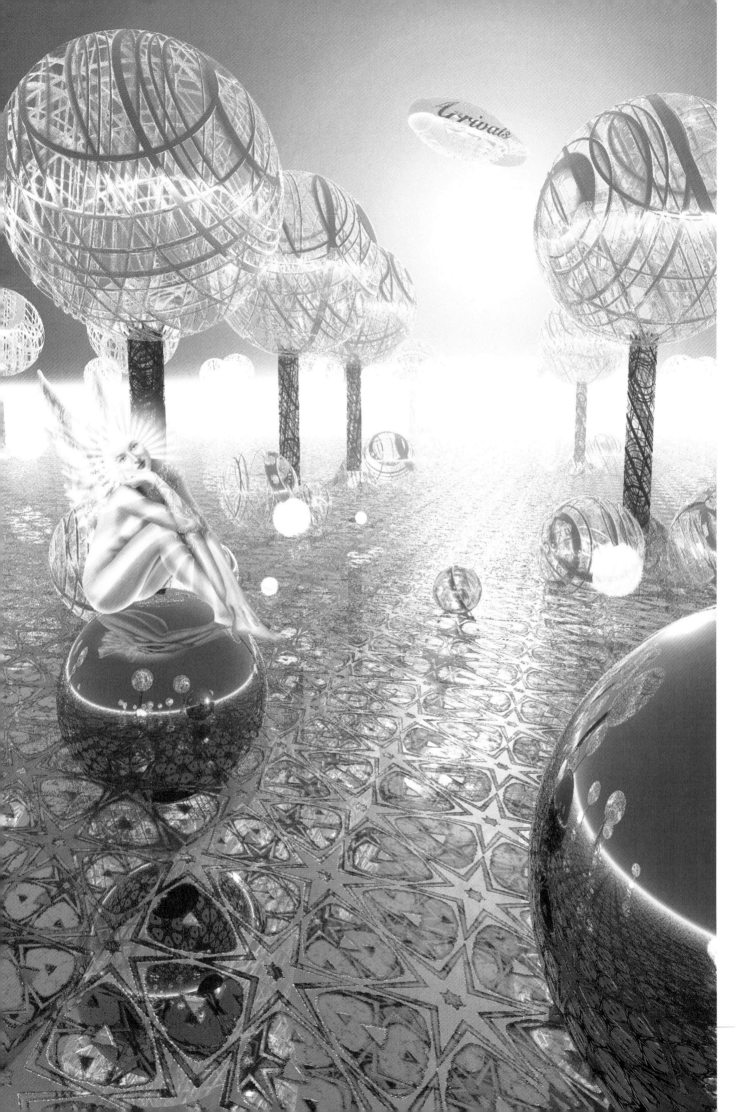

◀ The Edge of Heaven 1995
Card: Inner Eye Publishing
Poster design: Publisher undecided
Programs: KPT Bryce, Photoshop

A not altogether serious view of what
might be waiting for us on the other side.
The angel is making a reappearance from
Room With a View *(page 26).*

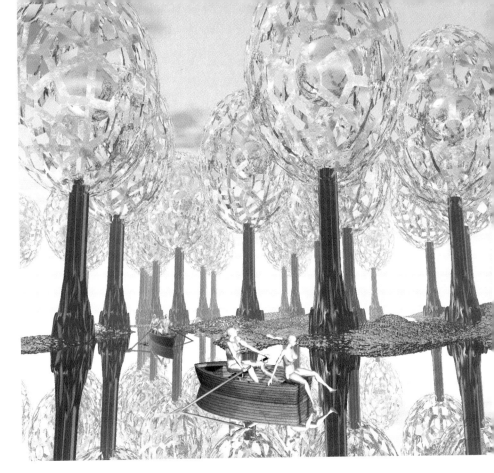

▲ Picnic in Paradise III 1995
Private work
Programs: Fractal Design Poser,
KPT Bryce, Strata Studio Pro,
Photoshop

▼ Cyboretum 1994
Sketch from *Journal*
of a Virtual Traveller
Program: KPT Bryce

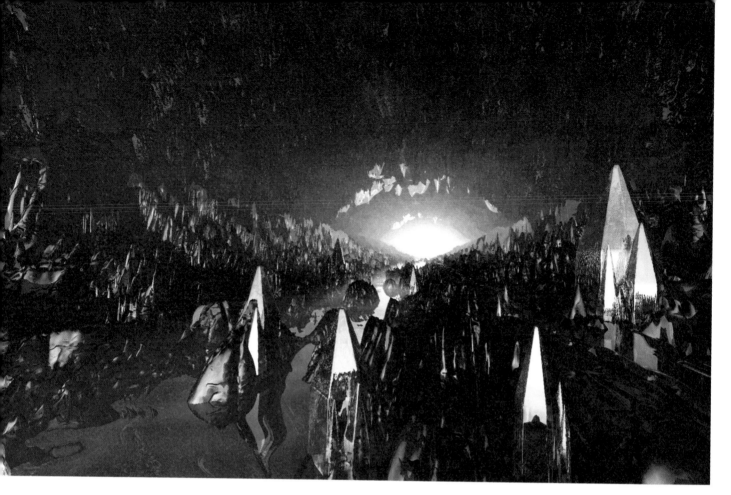

▲ **Cave Study I** 1995
Private work
Program: KPT Bryce

▼ **Cave Study II** 1995
Private work
Program: KPT Bryce

*A different viewpoint of the scene
in* Cave Dwellers *(opposite).*

Cave Dwellers 1995 ▶
Private work
Programs: Fractal Design Poser,
KPT Bryce, Strata Studio Pro,
Photoshop

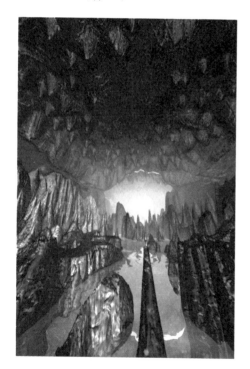

constructs. In Ziewe's virtual world, the sphere at the heart of each tree is what he calls a 'sound module'. This is a sensor that detects the traveller's approach and emits a characteristic ambient music, a parallel with a tree's rustling leaves, and also a chance for visitors to create their own soundtracks, which could be available on CD at the end of the journey (Patent Pending!).

Other factors, such as whether you fly, run or stroll through a scene, or if you touch things, could also produce music; these choices could also affect the weather or even the nature of the landscape. The possibility is there, too, of allowing each visitor's choices to leave a mark on the environment, so that the virtual world could permanently evolve through the responses to it.

Caves

Creating virtual caves has become a mild obsession for Ziewe. It is not hard to see why, as the results are so unpredictable that it really does look like exploration.

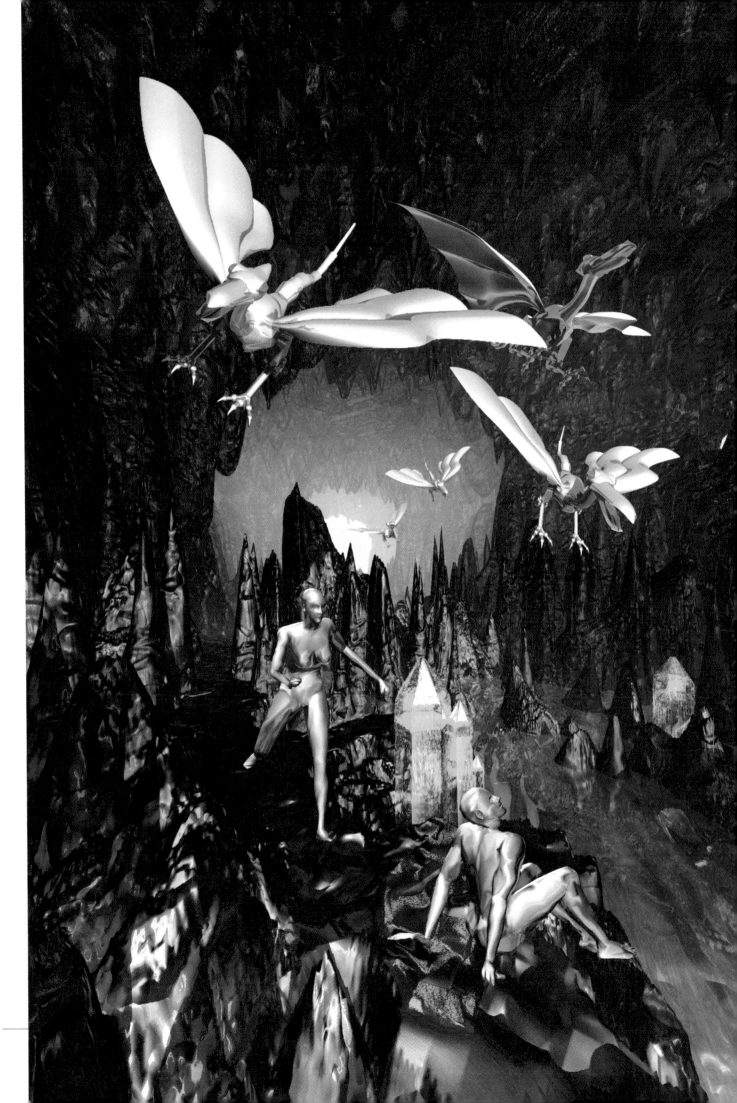

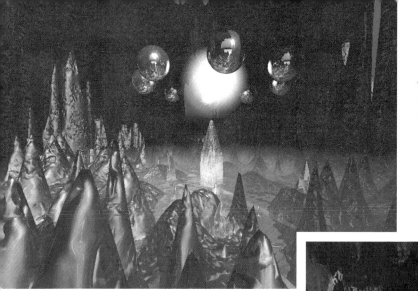

◀ **Mystic Cave I** 1995
Private work
Program: KPT Bryce

Subterranean Pool 1996 ▶
Private work
Programs: KPT Bryce 2,
Strata Studio Pro, Fractal Design
Power, Photoshop

*One of Ziewe's first experiments with
the new KPT Bryce 2 program which
allows the introduction of light sources
into the cave instead of having to rely
on virtual sunlight.*

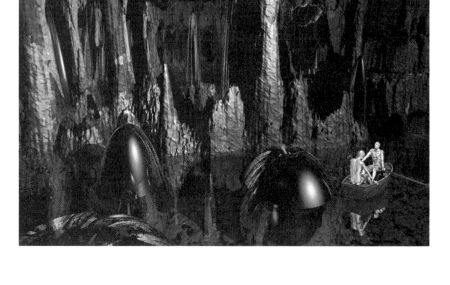

Crucible 1995 ▶
Private work
Programs: KPT Bryce,
Photoshop

▼ **Red Cave** 1995
Private work
Program: KPT Bryce

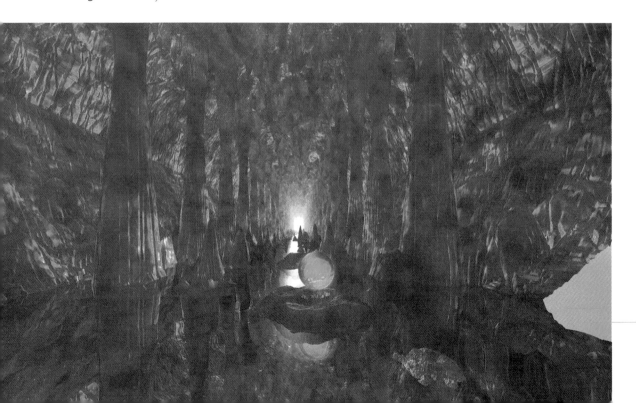

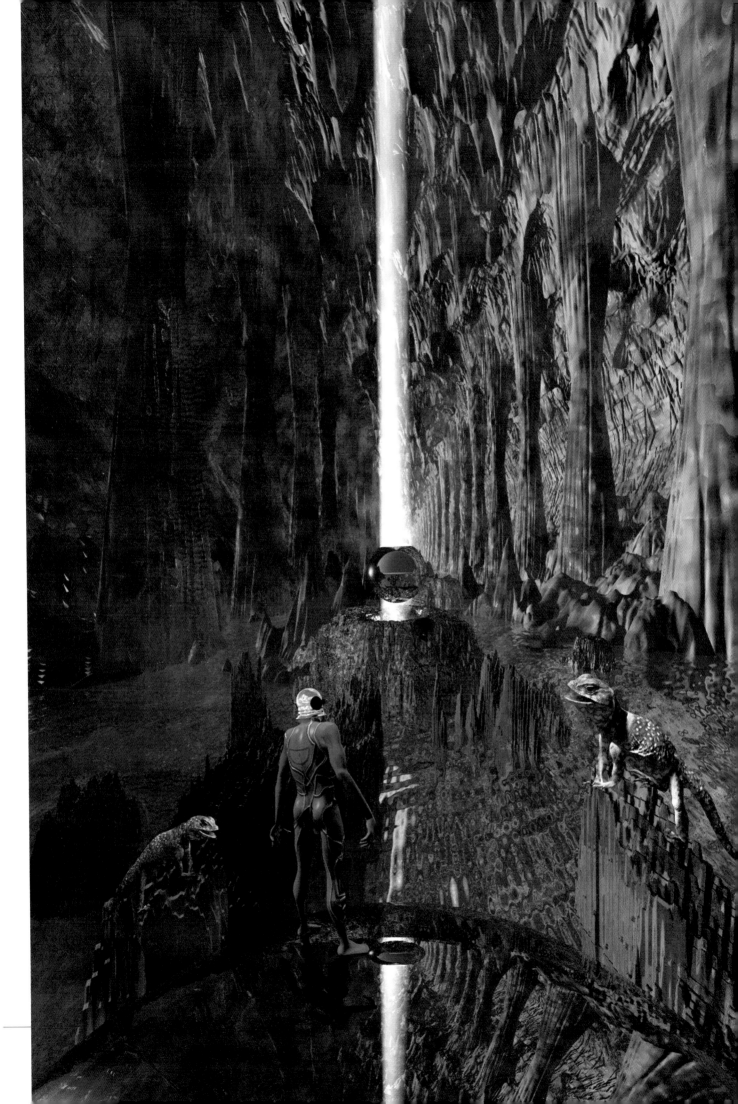

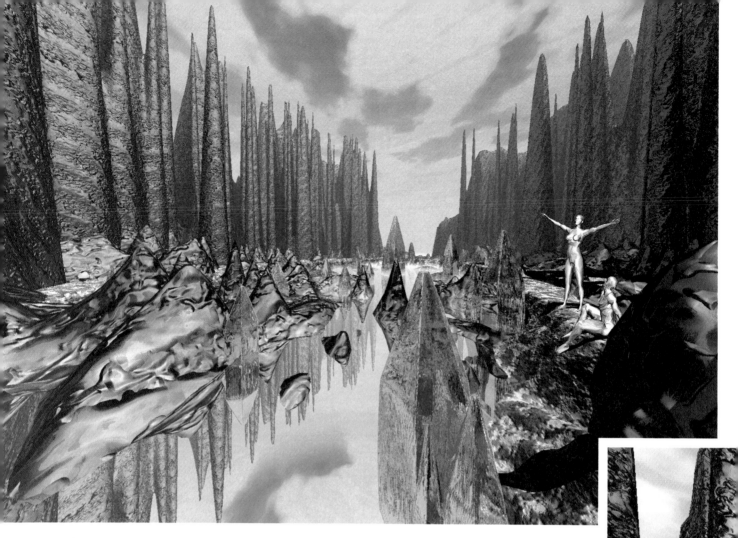

▲ Strangers in a Strange Land
1996
Private work
Programs: Fractal Design Poser,
KPT Bryce, Strata Studio Pro, Photoshop

His first step is to put the computer in Photoshop mode and take up
his computer graphics tablet. The picture starts on a pure black
background, so any marks made by the stylus show up white. The aim
of the picture is to create a contour map of the cave floor, with the
height of features being determined by their lightness of tone. The
stylus is set to work as a diffuse airbrush and two white bands are
introduced down either side to show where the cave floor rises to
become the walls. Then the improvisation begins; focussing the virtual
airbrush tighter, points and spots of white are planted here and there,
then blended to varying degrees with the background.

Texture is added by switching the airbrush to black, and smudging
and carving up the pattern to add ruggedness. How far to take this is a
matter of trial and error. When satisfied, the result is saved as a picture
file and moved from Photoshop into KPT Bryce.

The picture is converted into a 3D wire-frame image of the cave
floor, and can be eroded or the scale changed for dramatic effect. This

is then copied and flipped over to create the cave roof, which is brought down to join the floor, creating the basis of a new cave, complete with stalagmites and stalactites. Many options still remain though; as real caves are rarely this symmetrical, the floor can be flattened out, or the ceiling given a steeper arch.

Additional features can be introduced – such as water to any depth, clarity and stillness you choose. The rock texture follows, for which there are an infinite number of possibilities available. Also the position and strength of the light source can be chosen, and the kind of sky visible through the opening. The cave length can be changed by shrinking, stretching or even reflecting it against itself lengthways. The possibilities are in fact only limited by curiosity and time.

Ancient Lands

Texture is all-important in these pictures because of the clarity of resolution. Computer programs such as Photoshop and KPT Bryce offer a range of preset possibilities plus almost infinite parameters of control over them, but usually Ziewe prefers to work with natural textures. Almost anything you can draw or photograph can be used to generate a texture map that can be laid on to surfaces in a picture. For this purpose, he has built up a photographic library of, for example, stone, brick, wood, rust, flowers and

▼ **Petrified Landscape**
1995
Private work
Programs: KPT Bryce, Strata Studio Pro, Photoshop

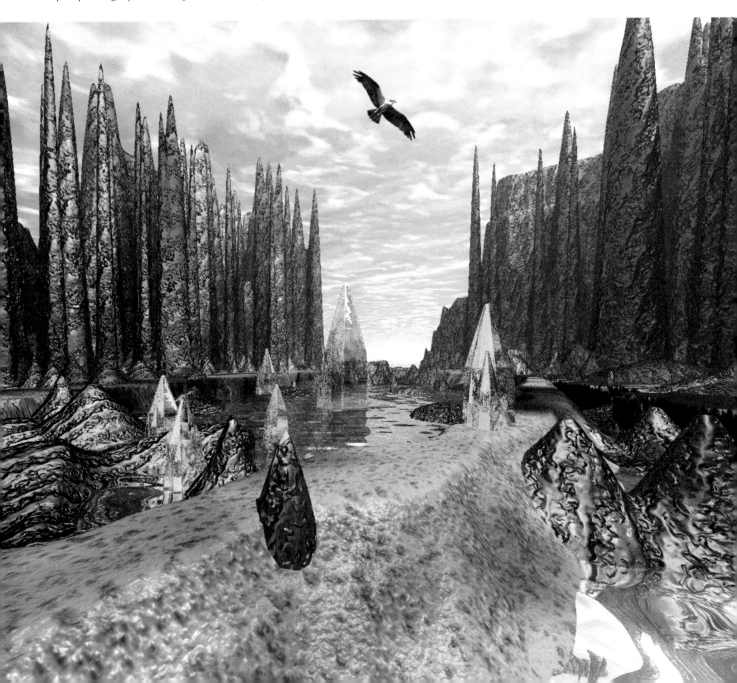

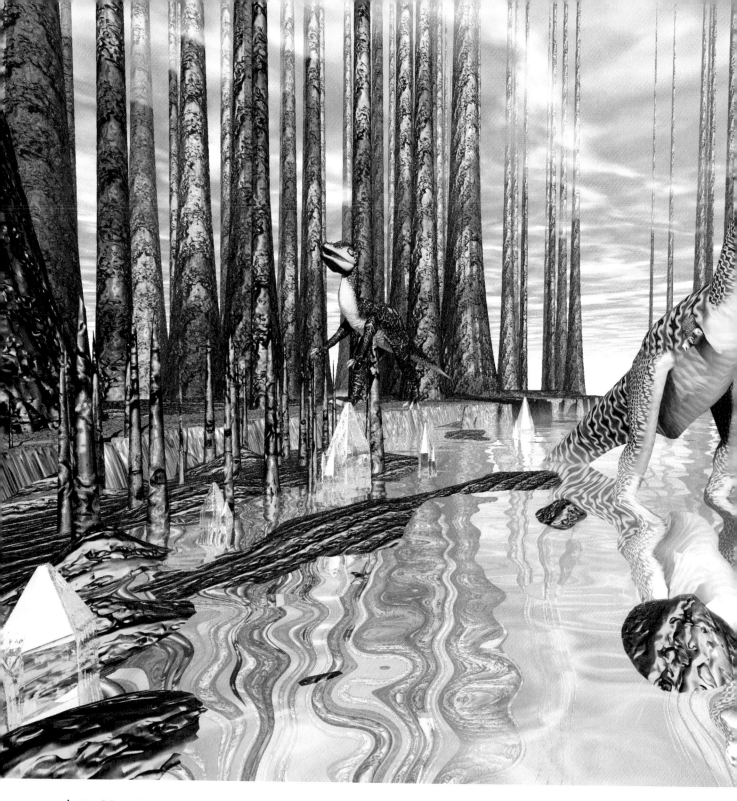

▲ **Prehistoric Swamp** 1995
Private work
Programs: KPT Bryce,
Strata Studio Pro, Photoshop

A wave filter in Photoshop was used
for the dinosaur reflections.

foliage; skies too, although he generally goes for simple skies and uses the program library.

'One thing I have never really properly experimented with yet is stormy skies. Perhaps because I generally hope for good weather when I go out. Traditionally you would have to make a decision about something like the mood of the sky early on in a painting, and then you'd be stuck with it. But with computers you can generate a range of moods, go to dinner while the computers are rendering them, then come back and make your selection. It can take a long time, though, to then create something meaningful out of this tremendous choice.'

In 1993, Ziewe was among the first people to buy the necessary equipment to store photographs on optical disk, which is where he keeps most of his reference pictures, as it is by far the most convenient way to scan them into the computer. A desktop scanner is all right for scanning in ordinary photographs if they are going to be used small or played around with, but otherwise the quality is not really high enough and they need to be taken to a professional repro house, which costs both time and money. Optical disks also take up much less room, although now with three drawerfuls of them, Ziewe is currently looking forward to getting CD-ROM equipment which should store the entire collection on just one or two CDs. An alternative is DAT tape, which has about three times the storage capacity of CD Rom, and onto which Ziewe copies his most important work for permanent storage in a safe deposit box.

4 Transcendental Travels

As a child, Ziewe had a very colourful and dramatic dream life and many of his dreams were of a decidedly cosmic, impersonal nature. He dreamed, for instance, of flying disembodied through space and landing on different planets, which being a child, he assumed were real. Often in dreams he was confronted with the concept of infinity and woke in a state of awe.

Strange Dreams

Later on in the 1970s he took up yoga after visiting India and cultivated the art of lucid dreaming. Basically, this is the trick of remaining conscious during sleep.

◀ Reflection 1995
Private work
Programs: Fractal Design Poser, KPT Bryce, Strata Studio Pro, Photoshop

The Last Cyborg 1995 ▶
Private work
Programs: KPT Bryce, Strata Studio Pro, Photoshop

Shortly before hearing that he was to be made redundant from his building society job, Ziewe was haunted by a recurring dream of wandering through a decaying cityscape much like this one, empty of life and light. When the news finally came he realized the dream was a picture of his life. He was head of his department and had done much to introduce new technology into his work, but although he enjoyed much of the work and the company of his colleagues, it was not really what he had meant to do with his life. He has always wanted to do what he is doing now. The robot is a dream symbol of that job, and also of a clinging ambivalence about high technology.

▼ Guardian of the Unknown 1995
Private work
Programs: KPT Bryce, Strata Studio Pro, Photoshop

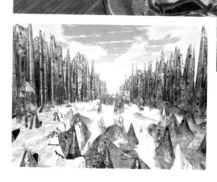

▲ Background sketch for
Guardian of the Unknown
(right)

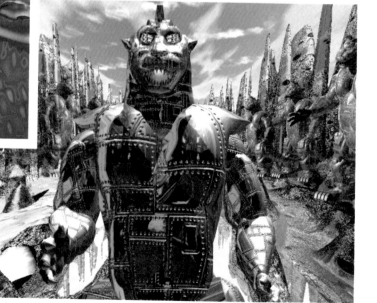

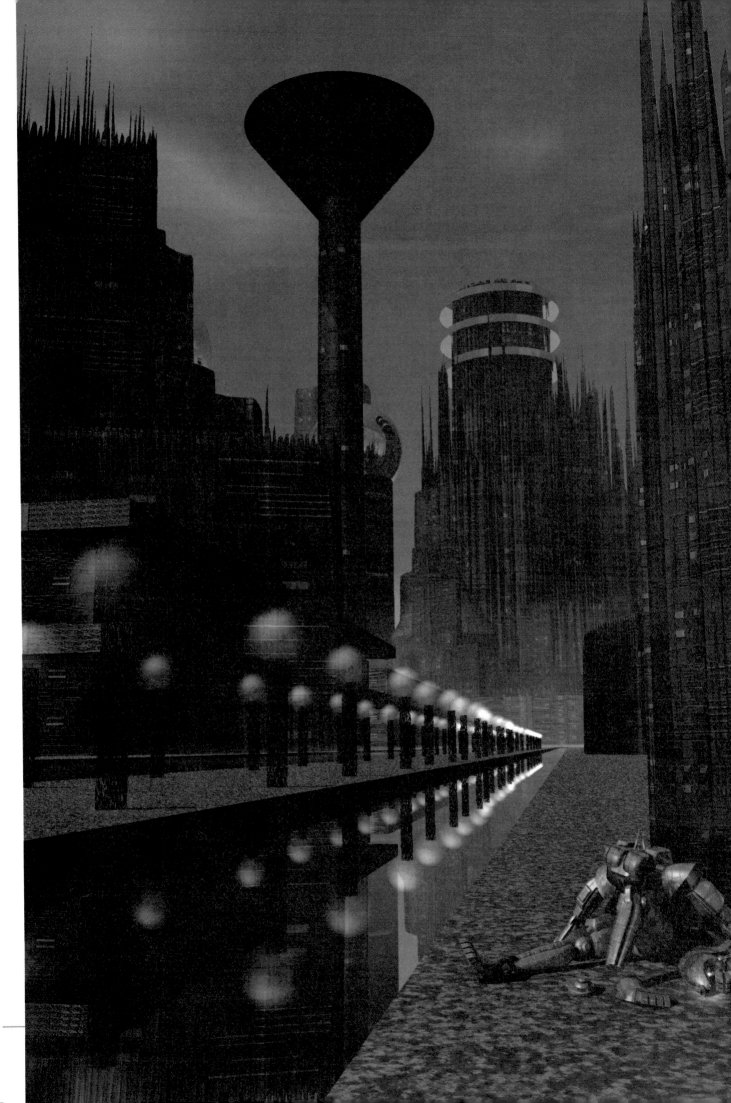

The Oval Mirror 1995 ▶
Private work
Programs: KPT Bryce,
Photoshop

*This image reminds Ziewe of one of
those unsatisfying dreams in which
you cannot quite find what you are
looking for.*

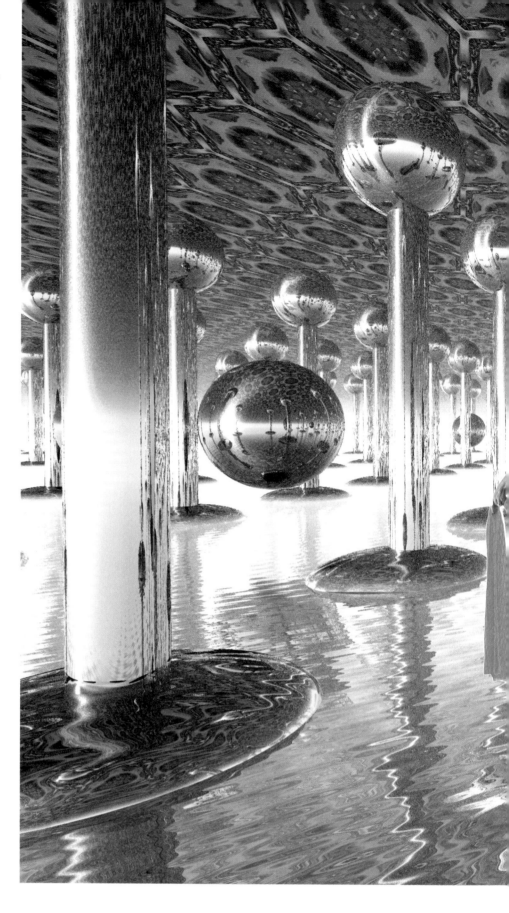

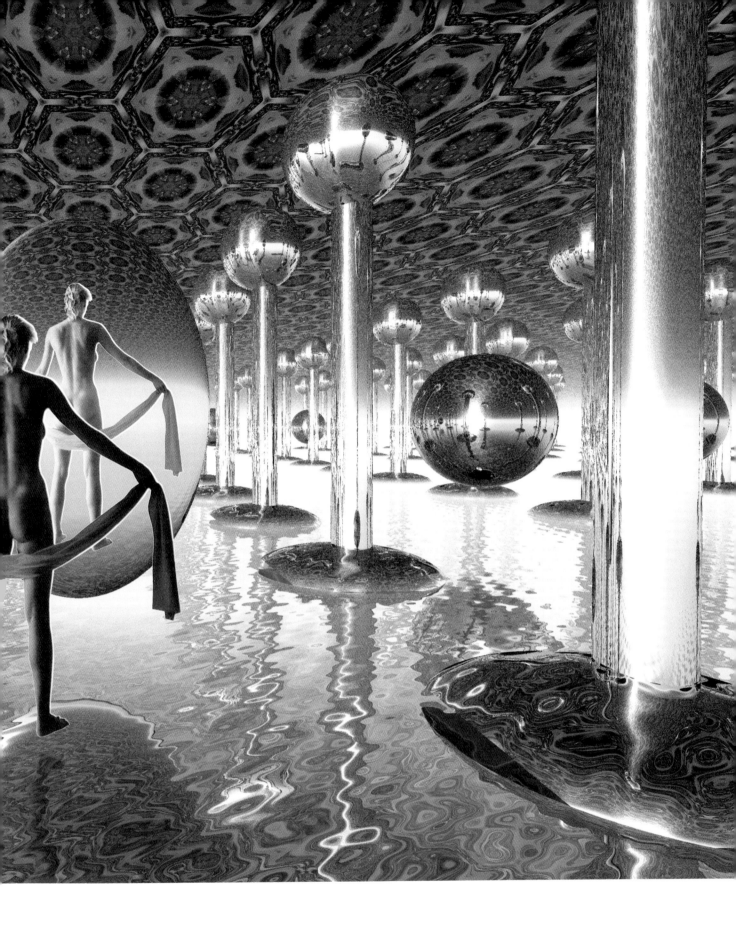

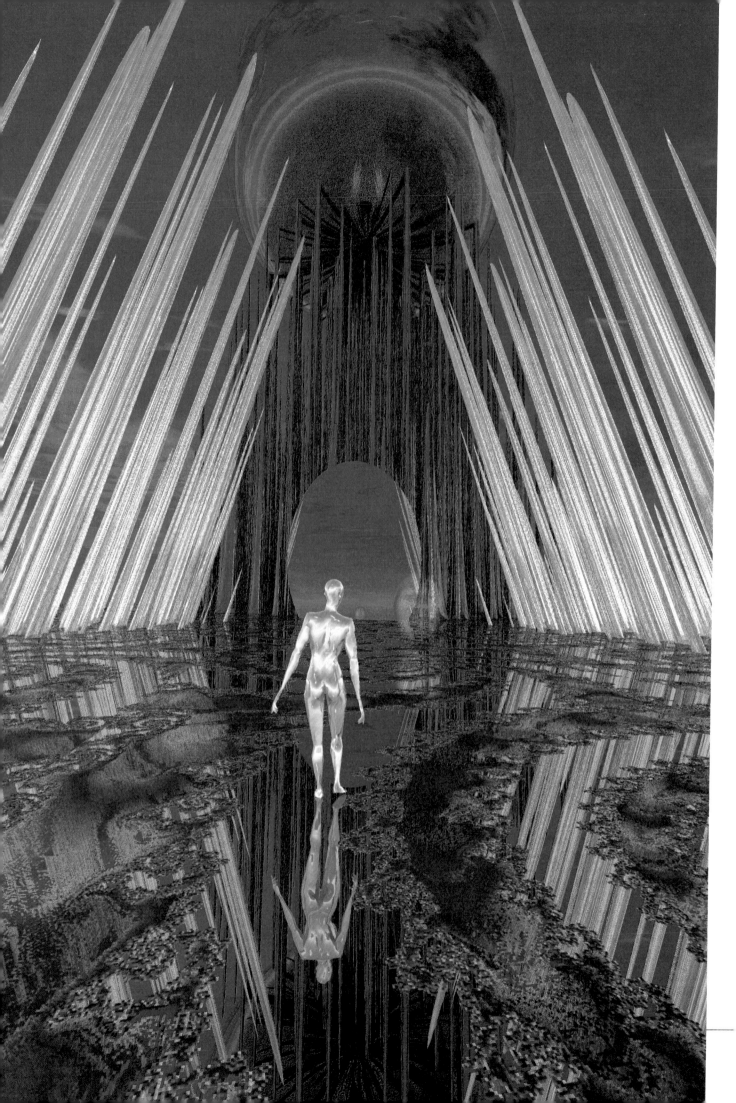

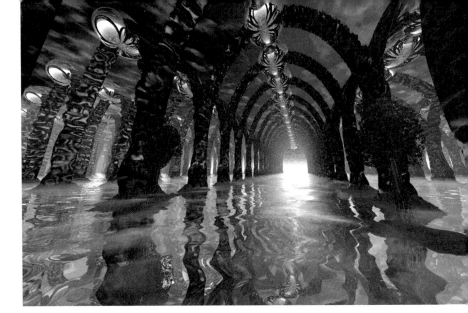

▲ Impending Storm 1996
Private work
Program: KPT Bryce

▲ Bunker 1996
Private work
Program: KPT Bryce

While doing his National Service in the German army in the late 1960s, Ziewe used to have to patrol an enormous wartime aircraft bunker set in the middle of nowhere. It had been built so well that it had defied all attempts at demolition, and was so large that trees were springing up inside it. At night it was extemely creepy and only lightly patrolled by the nervous conscripts. This is a fairly direct attempt at recreating the bunker, while the other two pictures on this page aim to capture the mood of the place.

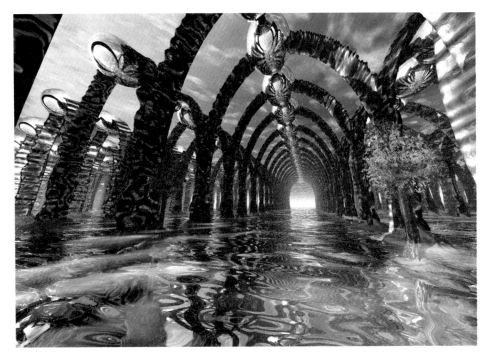

▲ Lonely Trees 1996
Private work
Program: KPT Bryce

◀ Expectation 1995
Private work
Programs: Fractal Design Poser,
KPT Fractal Explorer, KPT Bryce,
Strata Studio Pro, Photoshop

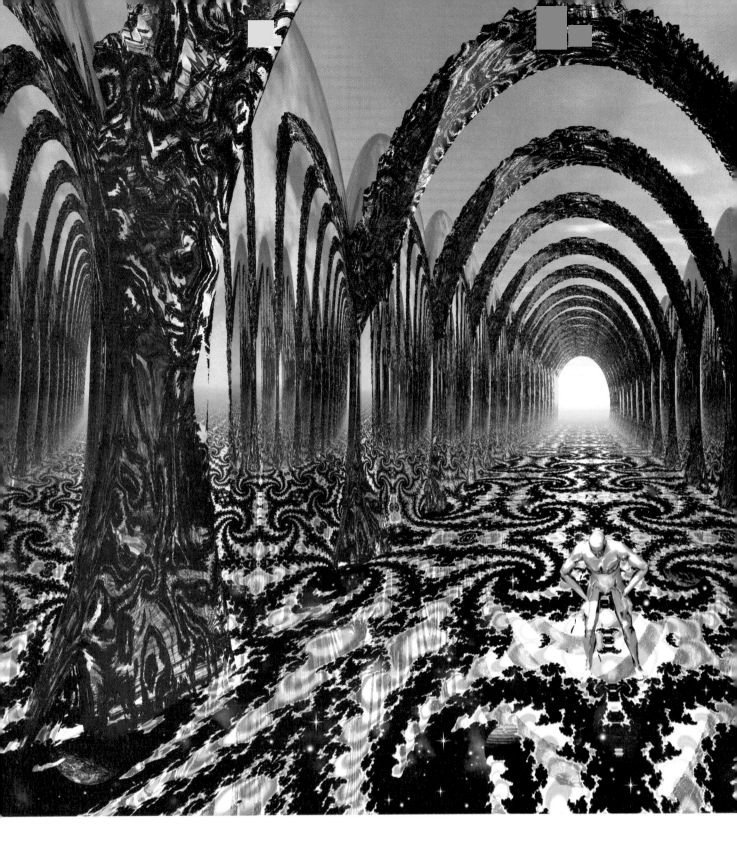

▲ **Mindspace** 1996
Private work
Programs: Fractal Design Poser,
KPT Fractal Explorer, KPT Bryce,
Strata Studio Pro, Photoshop

Or, for those familiar with the London
Underground: 'Mind the Gap!'

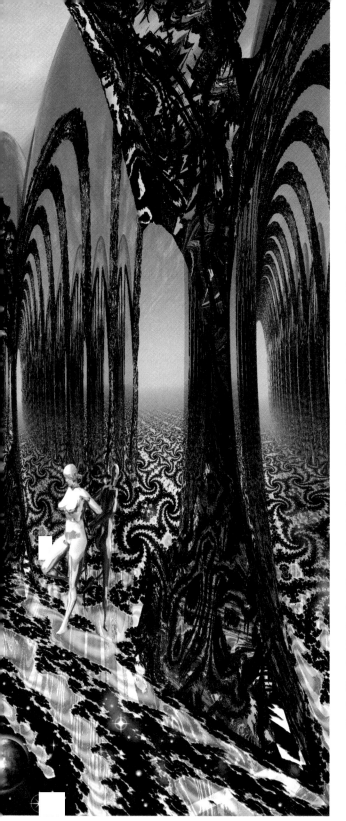

'In lucid dreams you are fully awake but in a dream world, so you can take charge of the experience to some extent. The environments or worlds you find in lucid dreams are partly similar to the real world but also different. It is an enhanced reality – the imagination has much greater freedom. The scenery seems on a grander scale and the colours can be so luminous they are almost uncomfortable till you get used to them. Then your consciousness in these regions becomes utter bliss. Everything is made of pure light and colour, and you feel very happy because you also are made out of light and are part of what you see.'

The level of consciousness is roughly, he believes, what the Theosophists termed the Astral or Devachanic Plane. Theosophy – the mystical school of thought founded in Victorian times by Madame Blavatsky and popularized by Annie Besant, a turn-of-the-century social campaigner – influenced Ziewe's thinking greatly for years. He has never claimed to be a Theosophist himself but enjoys their blend of Eastern mysticism and Victorian rationality, in particular the writings of C. W. Leadbeater who coined the term 'Devachanic' for the so-called Mental plane that he believed lay beyond the Astral. Of this area of consciousness, Ziewe says:

'When the mind liberates itself onto the Mental plane, it becomes more subtle, so more realities are possible. Abstract thoughts take on shape and there is a blurring of distinctions between, say, light, sound and smell. Some people can actually see colours as sound and vice versa; Kandinsky was one of them. We all have the ability to an extent, we can all imagine round or spiky sounds, but for some people it is very literal. In visual terms that state is what I try to capture in my pictures.'

Inner Sanctuaries

To try to capture the experiences and environments he found in lucid dreaming, Ziewe has long produced fantasy paintings in watercolour and airbrush, besides his abstract paintings.

He soon realized he could produce better results on a computer, especially when it came to the rich, almost psychedelic patterns which were part of those experiences. Before he had often tried to capture them geometrically, but there is no comparison to the fractal-generated swirls of pattern he comes up with today.

Another problem was that he found representational drawing very awkward, which is a fairly basic handicap if you want to be an artist. All this melted away once he got his hands on the keyboard of an Apple Mac, which made it possible to make these mental worlds real in a way that no painting can. As Ziewe says:

'Part of the beauty of computers is that you are not just creating a particular scene but a whole landscape which others can explore and experience.'

Potentially, computer-generated pictures like *Asuloca* (opposite) can be used in ways conventional pictures cannot, for example as scenery for fantasy films. Because they already exist in three dimensions, there is no need to *build* studio sets to resemble them.

Introducing realistic figures into purely artificial landscapes like these is fairly simple because the computer stores the images on screens which can be laid over one another, so whether the new elements derive from photographs or computer models makes little difference. You can actually buy computer models of horses, dolphins, monsters and dinosaurs – almost anything in fact – but they are

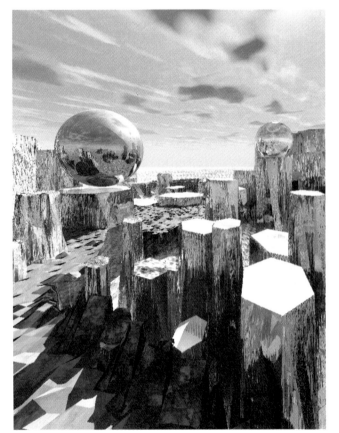

◀ Sketch for **Asuloca** 1995
Program: KPT Bryce

The disconcerting thing about computer art 'sketches' is that their degree of finish is almost the same as in the final article. This might make a conventional artist want to spit with envy, but in practice it just means that the computer artist gets a clearer idea of how the scene will look before irreversible decisions are made. The time which a conventional artist spends rendering and finishing off a sketch is generally, on the computer, spent generating the environment and figures. Only then can they be played around with in this manner, with technically perfect results every time.

Asuloca 1995 ▶
Private work
Programs: Fractal Design Poser,
KPT Fractal Explorer, KPT Bryce,
Strata StudioPro, Photoshop

*One of a new set of illustrations for a fantasy story
of the same title, which Ziewe began about fifteen
years earlier, originally illustrating it with airbrush and
watercolour. The idea was to see how effectively the
computer can be made to do the same kind of work.
So far the result is a great improvement.*

▼ **Light Riders** 1996
Poster: Unpublished
Programs: Fractal Design
Poser, KPT Bryce 2, Strata
Studio Pro, Sculpt 3D,
Photoshop

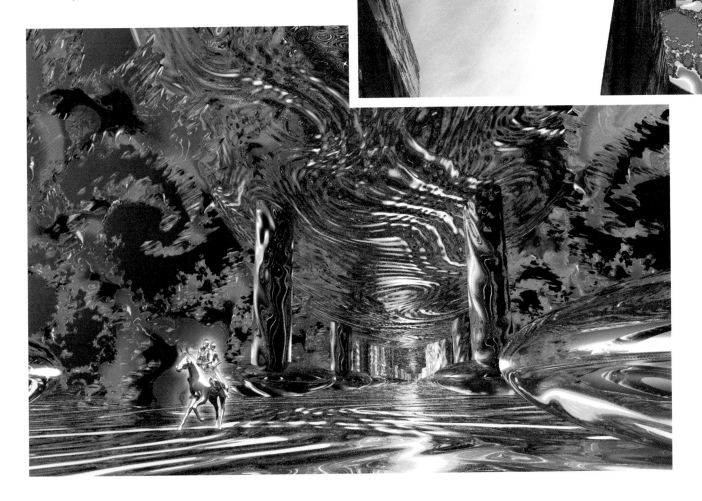

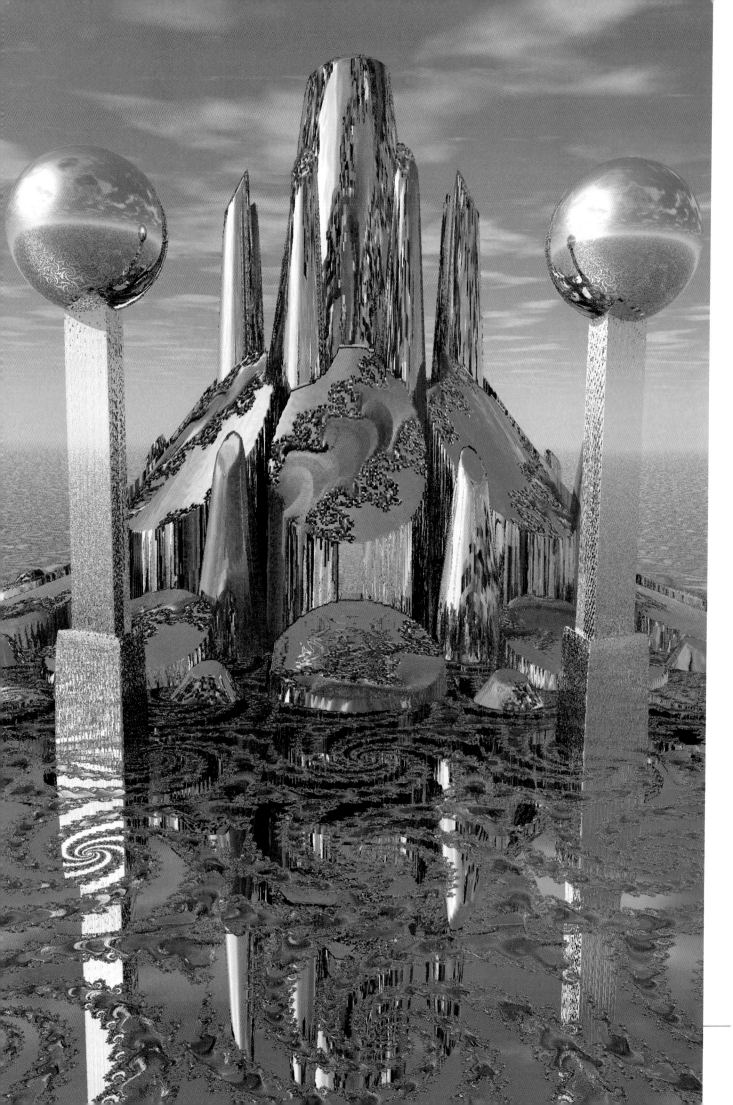

expensive and Ziewe generally prefers not to use them for his own work. For, though they have the advantage of being able to be posed and photographed from just the angle you want (unlike real animals), they also lack a certain vitality. He is, however happy to use them in his commercial work, when it is worth the client's while to invest in them, and as he usually gets to keep the model afterwards he has built up quite a zoo-full, but is sparing in their use.

Sometimes he might take one of these constructs as a starting point, to save having to create the physique of a monster completely from scratch; but even this is rare. Deciding when or not to use a commercial model is a matter of instinct for Ziewe, as anything that comes too easily feels somehow like cheating to him.

The practicalities and responsibilities of family life put an end to Ziewe's yogic experiments, but the quality of the lucid dreams he experienced is something he aims to capture in his art. In fact, he finds a great similarity between lucid dreaming and his late night explorations of the strange worlds that materialize on his computer screen. The great difference is that now he is able to capture his finds instantly as if with a camera, instead of trying to approximate them later with ink and watercolour. The dreamy symbolism of pictures like these is less controlled than people tend to imagine. Ziewe does not start with an idea or point he wants to illustrate:

'It is a very unconscious process. Ideas develop almost like when Max Ernst sponged colour onto paper, saw faces in it and then brought them to life.'

Often the starting point is a purely technical experiment and the imagery or story emerges more or less of its own accord; also, the mood or significance of a piece does not always become clear to the artist until much later, if even then. He has often had

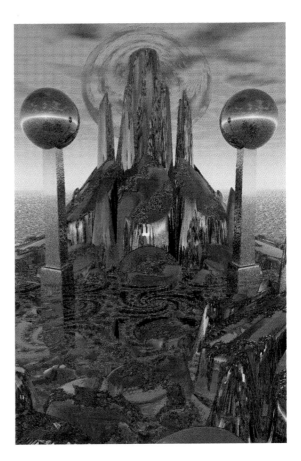

Sketch for Landmark in Cyberspace (opposite) ▶
Programs: KPT Fractal Explorer, KPT Bryce, Photoshop

A Polar Co-ordinates filter in Photoshop was used to obtain the whorling cloud effect.

◀ **Landmark in Cyberspace** 1995
Private work
Programs: KPT Fractal Explorer, KPT Bryce

Temple of Venus 1996 ▶
Poster design: Wizard & Genius
Programs: Fractal Design Poser,
KPT Fractal Explorer, KPT Bryce,
Strata Studio Pro, Photoshop

An exercise in psychedelia.

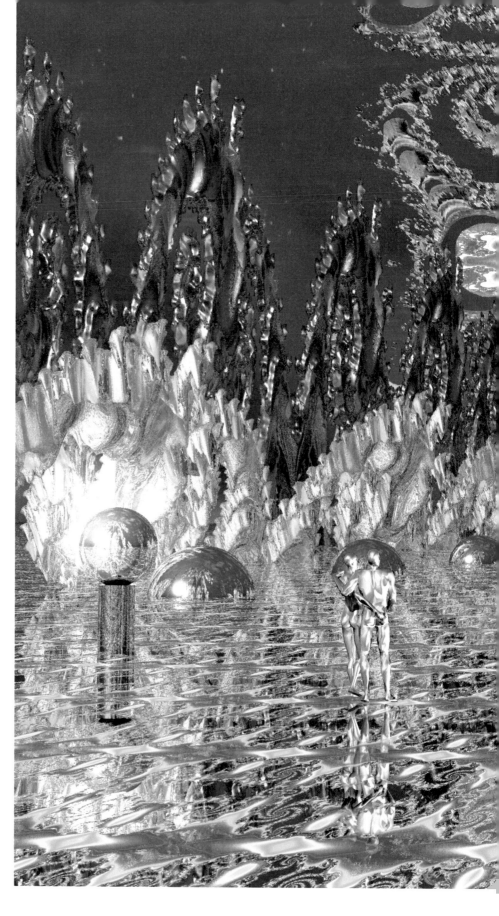

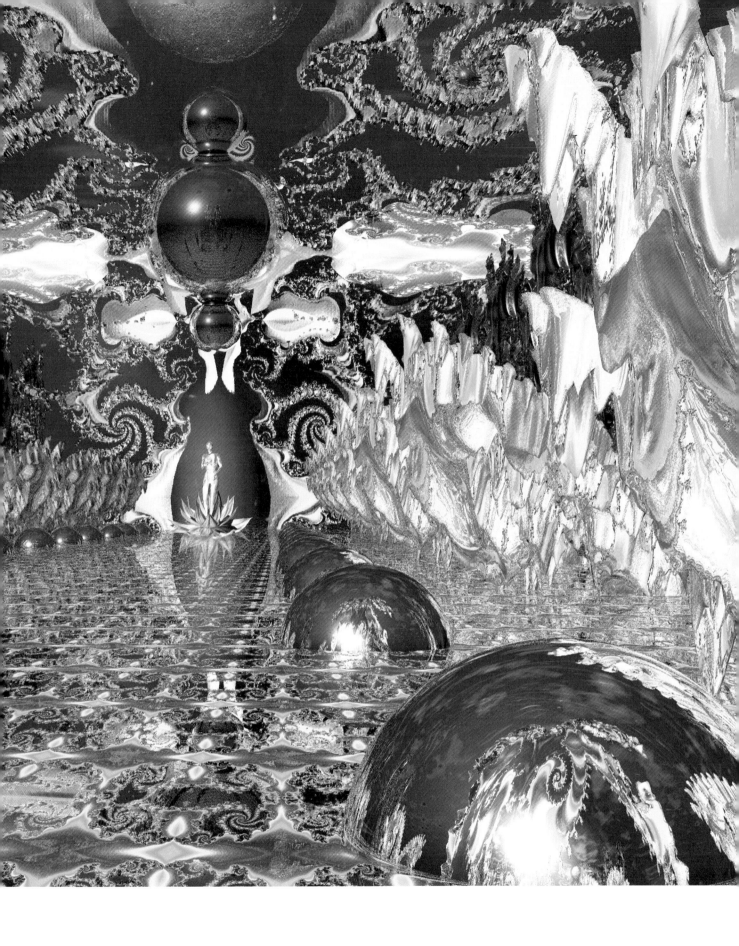

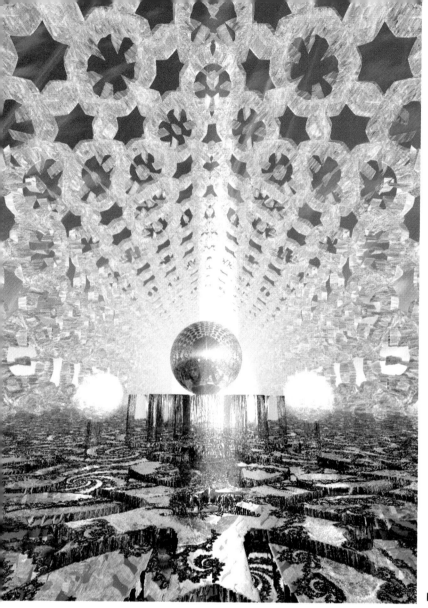

The Magician 1996 ▶
Private work
Programs: Fractal Design Poser,
KPT Fractal Explorer, KPT Bryce,
Kai's Power Tools Spheroid
Designer, Photoshop

◀ Sketch for **The Magician** (opposite)

people point out things in his pictures that come as a complete surprise to him. These symbolic pictures come from another territory of the mind – the dream level in which issues can be tackled symbolically and meaningfully in a way that is impossible in the real world.

Ziewe's philosophy of life and art owes as much to Carl Jung as to the Theosophists he studied intensely for a while: 'I have to confess that I am a really strong Jungian follower; I totally agree with his theories about dreams, archetypes, the collective unconscious, the Self and so on.'

Jung's theory about the nature of the Self as opposed to the Ego, and the individual's usually doomed quest through life for the Self, is of particular importance and is probably the main recurring theme of Jürgen's work. The light of pure consciousness at the centre of creation; the temple and the sphere are all Jungian symbols of the Self – reflective spheres in particular. This is hardly surprising, says Ziewe, as children are naturally fascinated by both mirrors and spheres. As Lewis Carroll demonstrated with *Alice Through the Looking Glass*, the childish imagination tends to see mirrors as gateways to other dimensions because everything in them is reversed, while spheres of one kind or another – from bouncy balls to Christmas tree decorations – are linked with their earliest pleasures in life. The sphere or circle has also been said

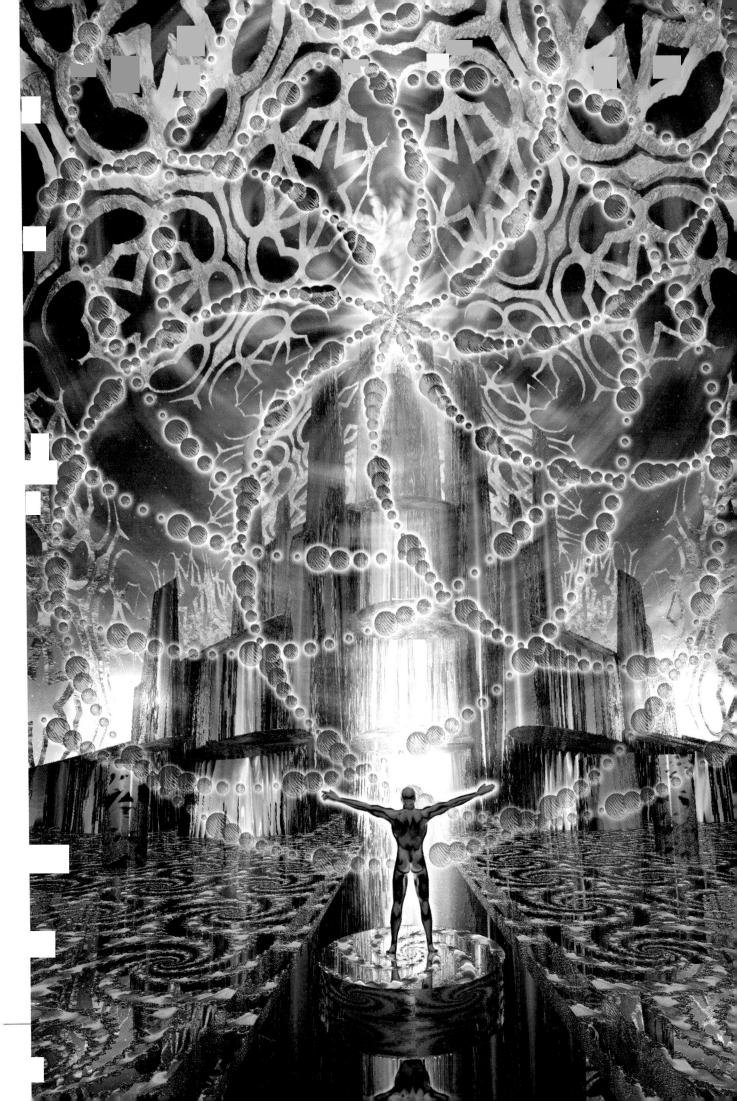

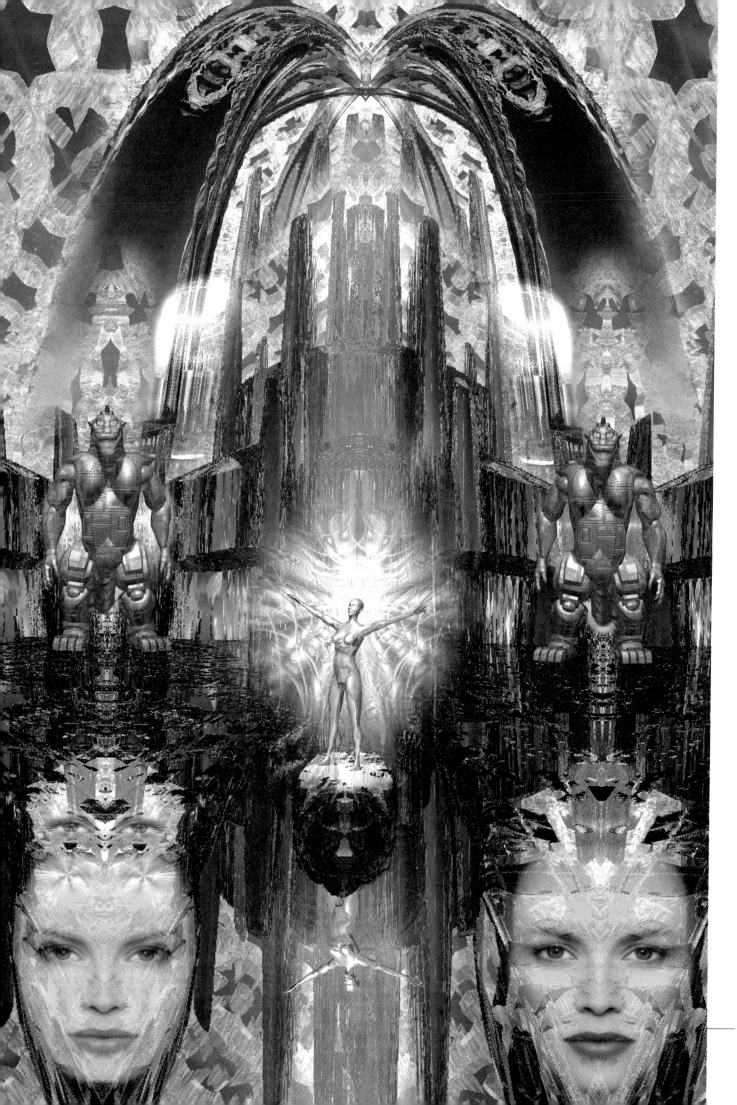

◀ The High Priestess 1996
Private work
Programs: Fractal Design Poser,
KPT Fractal Explorer,
KPT Bryce, Strata Studio Pro,
Morph, Photoshop

*This composition employs the full range of
Jurgen's programs and techniques – including
morphing, modelling fractals and lucky
accident. The twin priestesses were morphed
from fashion portraits of four or five different
models. Curiously, no matter how sulky or
temperamental the original models appeared,
when morphed together they turned into
pure, angelic beings like this. The 'Guardians
of the Threshold' were developed from an
off-the-shelf computer model and then
modified in Strata Studio Pro, rather than
being built up from scratch as usual. This
saved time but the end result is probably
little different.*

Shrine 1996 ▶
Private work
Programs: KPT Fractal
Explorer, KPT Bryce

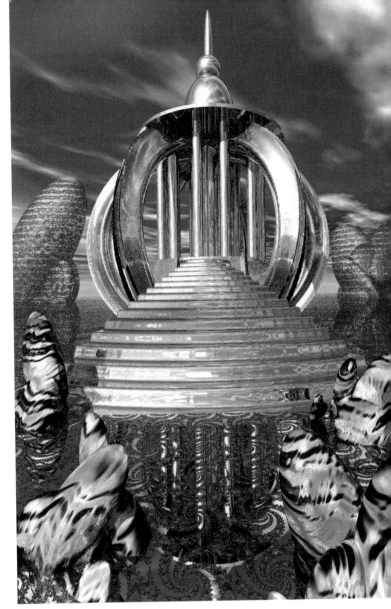

to represent our relationship with nature and has appeared as a symbol from early sun-worship to modern religion, from Tibetan mandalas to blue prints for new cities.

In dream symbolism the shiny sphere represents the Self particularly well because its reflections embrace almost the whole landscape at once. It presents an otherwise impossibly wide view of the world. Flat mirrors on the other hand tend to stand for our reflections on the Ego, seeing ourselves as outsiders do. In uncontrolled dreams the appearance of one or the other points to the area of one's life in need of balance. In lucid dreaming and art they point to one's main area of interest. Ziewe says:

'Probably the whole point of why I make pictures is to try to find the origin of pictures, ideas and in the end, being. The whole idea of my first cards and exploring the New Age market was to express these ideas visually.

'The Mental or Devachanic plane has always been a beacon for me, even in my abstract work. I am always looking in my pictures for a spiritual light.

'I feel we are sometimes almost hindered in our perception because we're tied down to the material world. If you go into the realm of pure aesthetics, with a heightened awareness of harmonics, colour and shape, you can find a sense of beingness, which can be absent from physical life because of its distractions.'

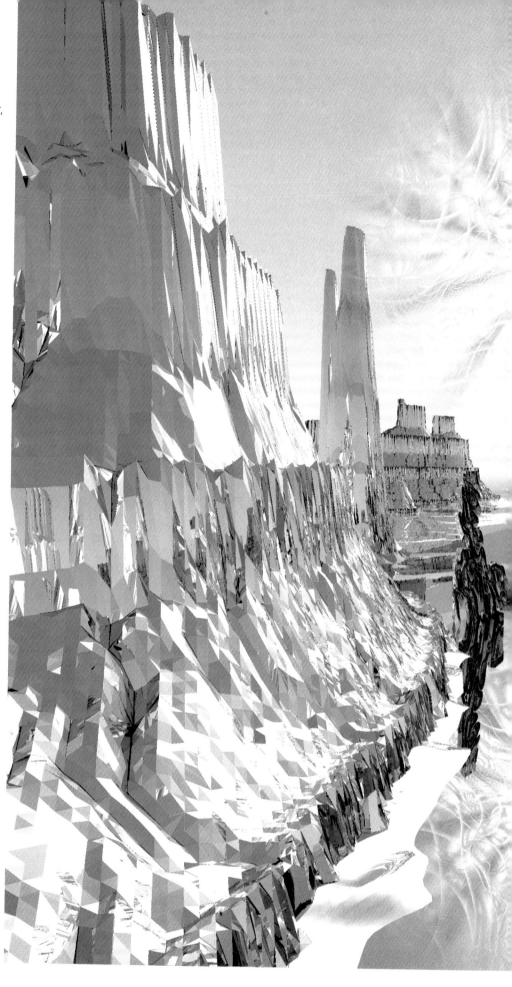

The Beacon 1995 ▶
Private work
Programs: Fractal Design Poser,
KPT Fractal Explorer,
KPT Bryce, Strata Studio Pro,
Photoshop

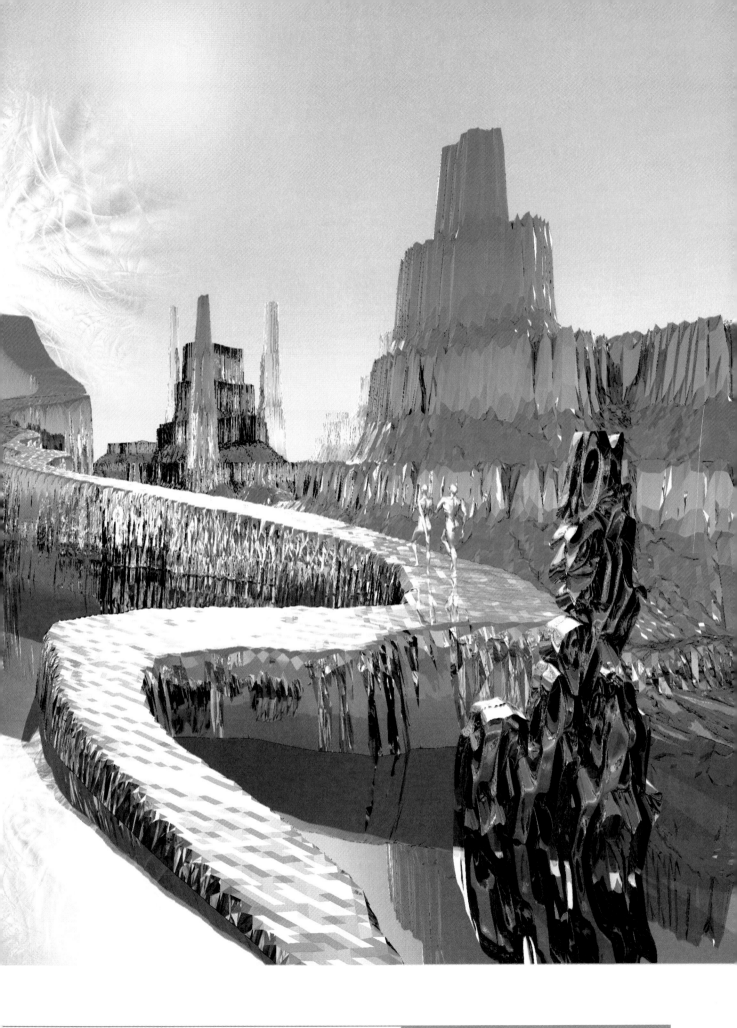

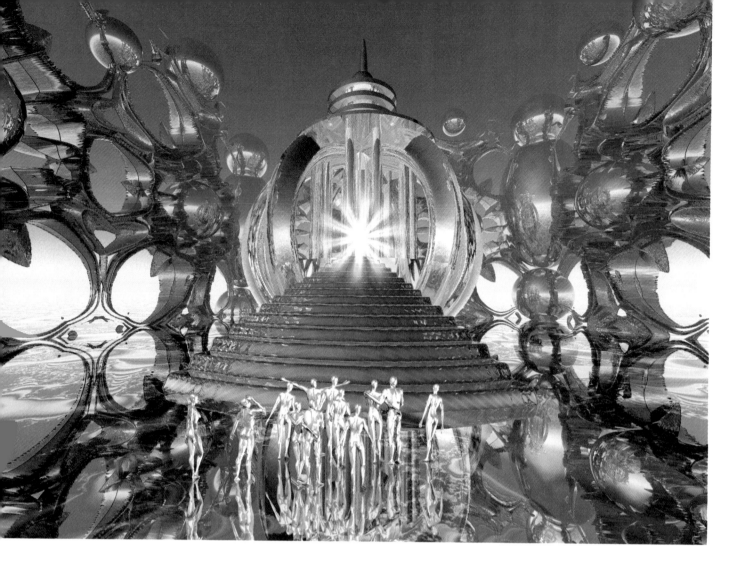

▲ Gateway To Infinity 1996
Private work
Programs: Fractal Design Poser,
KPT Bryce, Strata Studio Pro,
Photoshop

The Calling 1995 **▶**
Private work
Programs: Fractal Design Poser,
KPT Fractal Explorer, KPT Bryce,
Strata Studio Pro, Photoshop

'When I used to settle down to paint, it felt almost like a homecoming. It was almost as if something said: "Welcome home, this is where you belong." It was almost an ecstasy, full of joy. There was a tremendous sense of relief at being freed from physical concerns, a mood of everything always being all right, even the bad things in life. The most important feeling one can have is, I believe, this sense of beingness, of peace in the truest sense; a feeling of "I am here where I am meant to be".

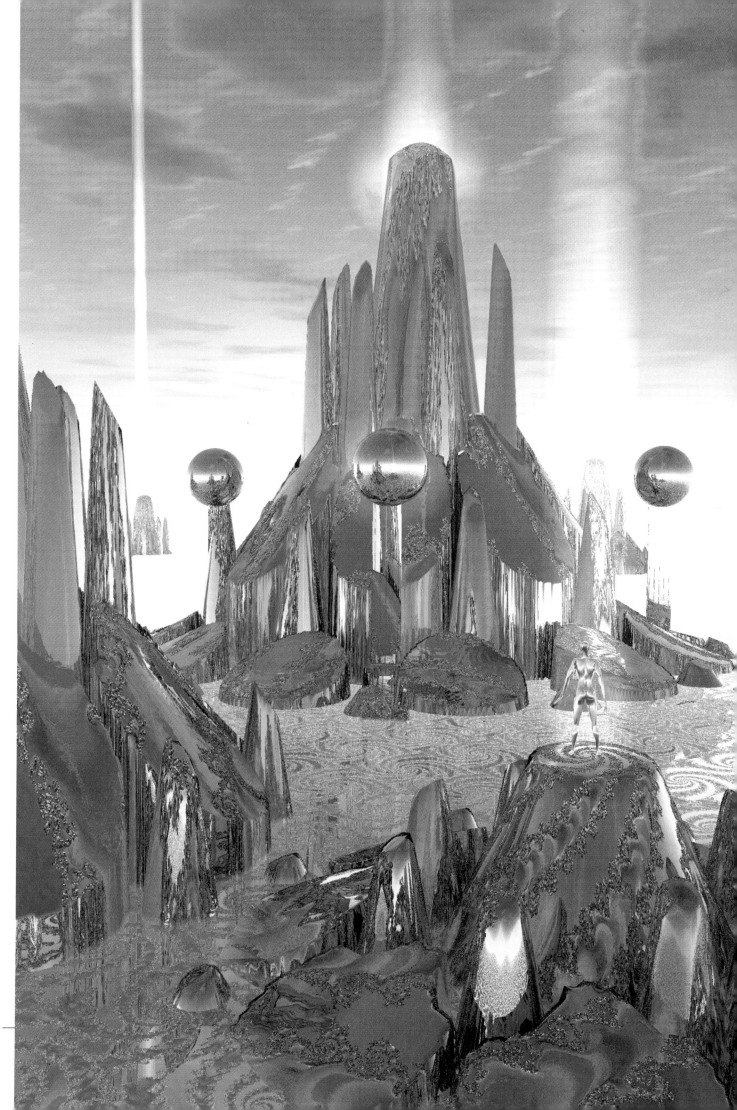

Devachanic Realms

As an artist Jürgen Ziewe began with abstract painting and he still feels a constant pull in that direction. For recreation he still occasionally produces Abstract paintings on the computer in his original post-Kandinsky style, but sadly the computer is now the only place he has enough room for them, as his studio is full of electronic equipment. One day, he aspires to another studio in the garden, where he can get out his brushes and turpentine and paint on a grand physical scale again.

For the moment, though, he is happy enough with what he does. In fact, creating the 'Thought Form' pictures in this section feels to him to be almost identical to his large scale (and very three-dimensional) paintings, lacking only the smell of turpentine and oils. Curiously, they meet much more enthusiasm. People are much more able to see them as he does, as a kind of visual music and abstract drama of form and colour. This means that in a roundabout way he has almost returned to his starting point.

▼ **Thought Form II** 1995
Private work
Programs: KPT Fractal
Explorer, KPT Bryce

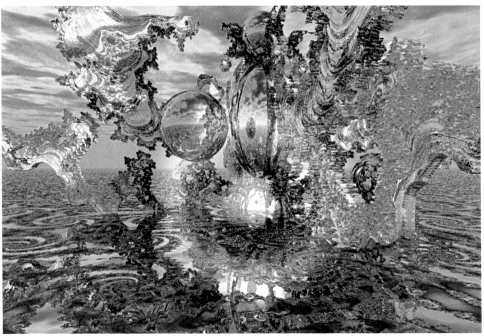

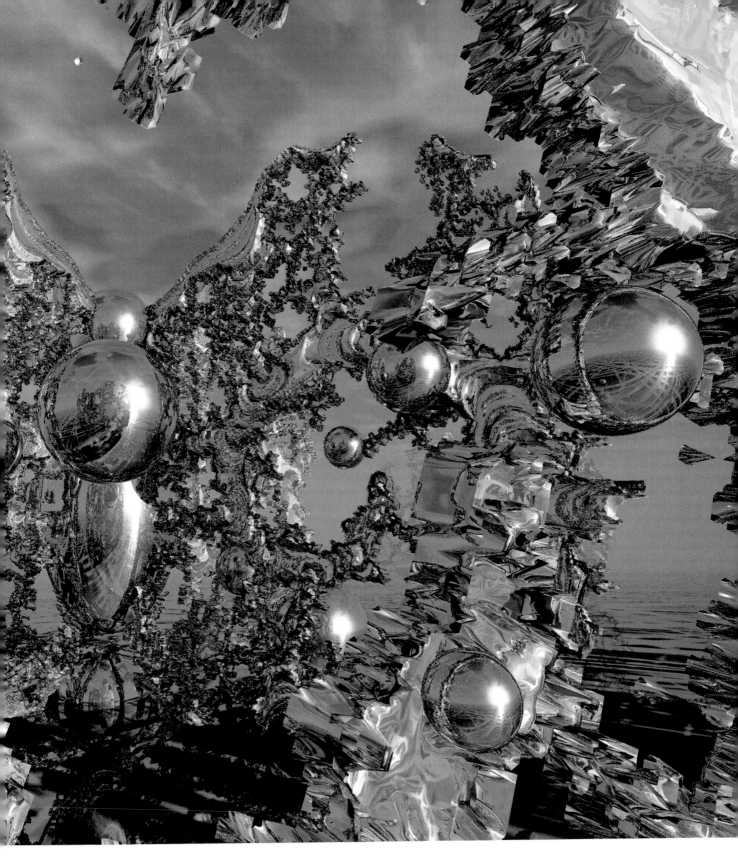

▲ **Thought Form I** 1995
Private work
Programs: KPT Fractal
Explorer, KPT Bryce

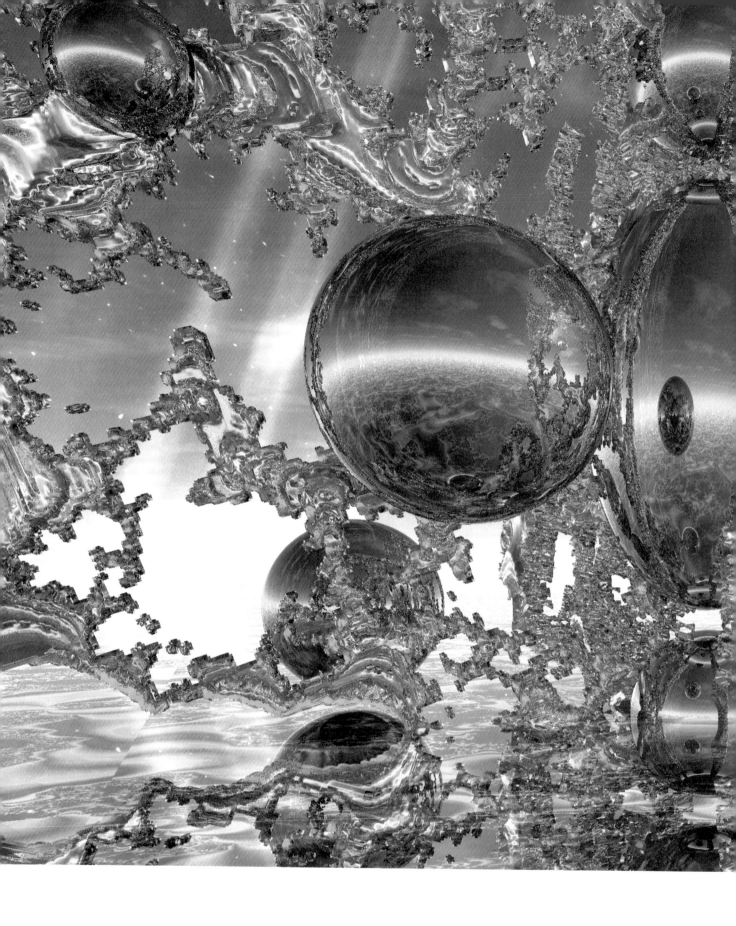

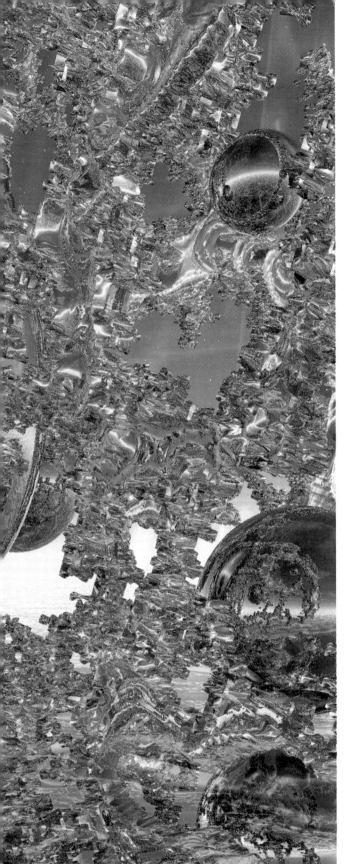

The pictures in this final section come very close to being pure abstracts and Ziewe is currently exploring the intriguing possibility of animating them as light displays to be projected onto large screens in rave clubs, with facilities to allow the movement to be synchronized with the music, or under the DJ's control.

Although he is far from blind to the much publicized dangers associated with raves, Ziewe does not share the current widespread anxiety about the rave scene of his own generation.

'There seems to be an ironic transfer from churches to clubs among young people seeking spiritual fulfilment. The ecstatic trances they seem to go into at raves, with or without drugs, are very similar to tribal religious experience. It is as if they are trying to recapture the underlying rhythm and togetherness of tribal life which modern society has taken away from us. And it is all created by technology – the drugs, music and visuals – a totally artificial environment.

'Perhaps it is time for people to accept this, face up to it and make sure the tremendous creative potential is not used for purely self-indulgent ends, with the youngsters ending up losing their way. Art is perhaps one way of directing this. Images can have a mandala-like influence on mood – a focus on unity or perhaps a reminder of it.'

Thought Form V 1995 ▶
Private work
Programs: KPT Fractal
Explorer, KPT Bryce

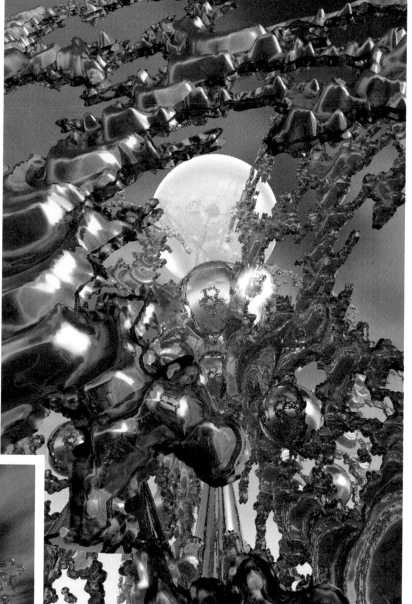

▼ **Thought Form IV** 1995
Private work
Programs: KPT Fractal Explorer,
KPT Bryce

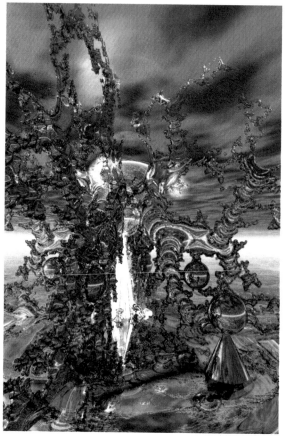

'In horror films, new technology has a dreadful potential
for disturbing people, but I believe it can be just as
powerfully used for the opposite purpose.

'My whole reason for painting has always been a
spiritual search for truth, an attempt to come close to
some mystic vision, to get close to the pure light of
consciousness. Computer imagery is one way to pierce
the veil.'

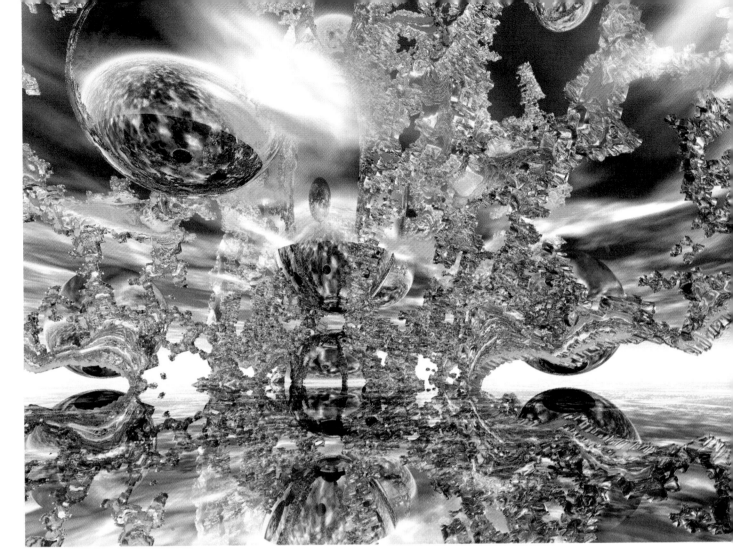

▲ **Thought Form VI** 1995
Private work
Programs: KPT Fractal Explorer,
KPT Bryce

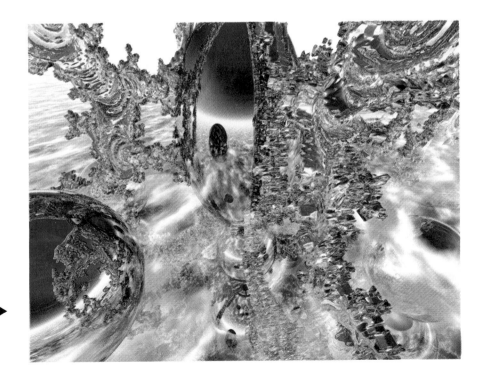

Thought Form VII 1995 ▶
Private work
Programs: KPT Fractal
Explorer, KPT Bryce

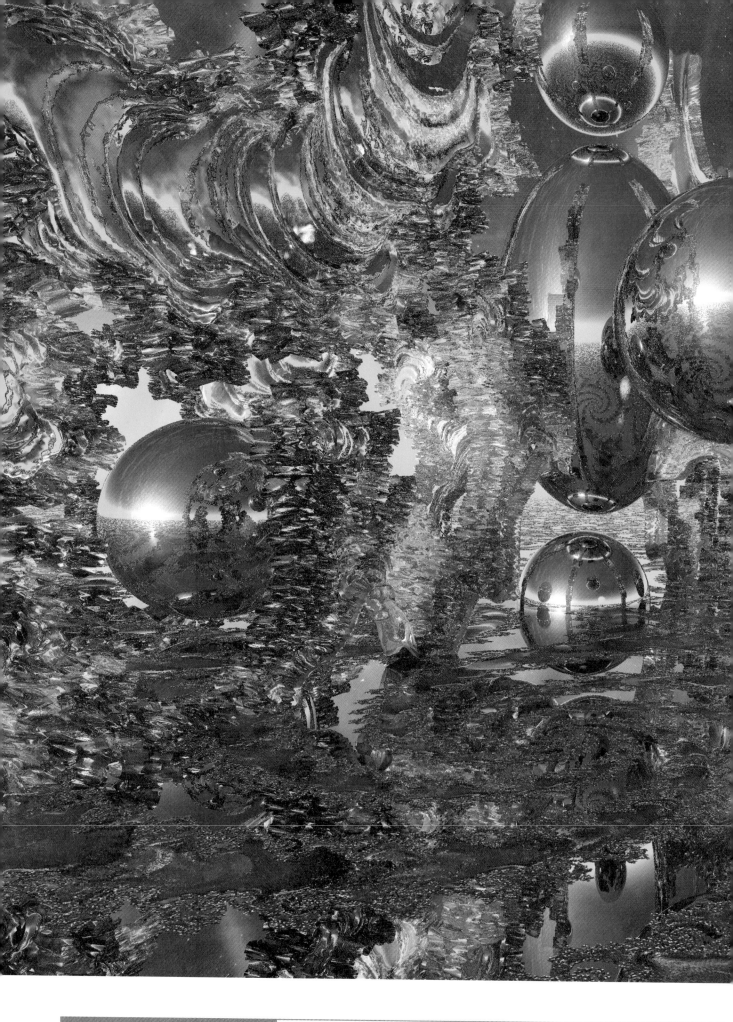

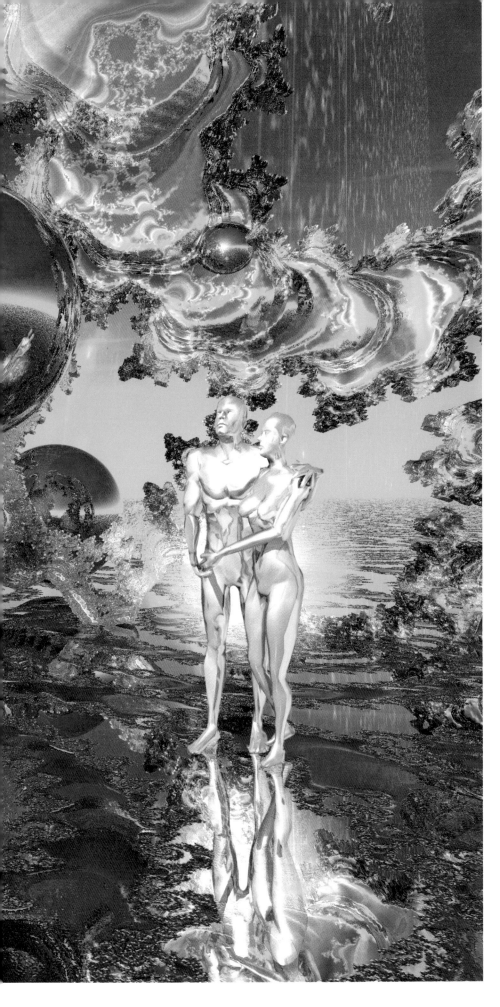

◀ **Lucid Dreams** 1995
Private work
Programs: Fractal Design Poser,
KPT Fractal Explorer,
Strata Studio Pro, Photoshop

*This is a good example of the
unpredictability of some pictures.
Until the light source was introduced,
Ziewe had no idea how this would
look, particularly the reflections and
play of light in the rope-like structure
above the couple's heads. These
structures and the floor design were
generated from fractals.*

Ziewe's art is a search for mental spaces that are impossible on earth. Something like the Theosophists' Astral plane, where ideas take form without first having to consult the laws of terrestrial physics. His instrument or vehicle is the computer, from which emerge strange new forms of beauty. His art gives us glimpses of a future made possible only by the microchip, but at the same time his computer visions are strangely reminiscent of those mystical dreams which have haunted people since the beginning of time – visions of the realms of angels.

▼ Thought Form VIII 1995
Private work
Programs: KPT Fractal Explorer,
KPT Bryce

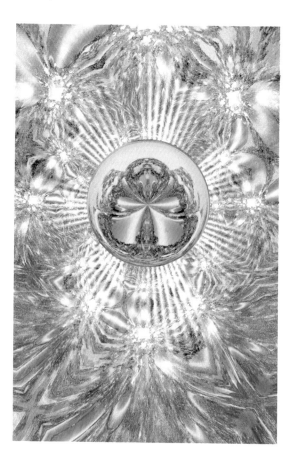

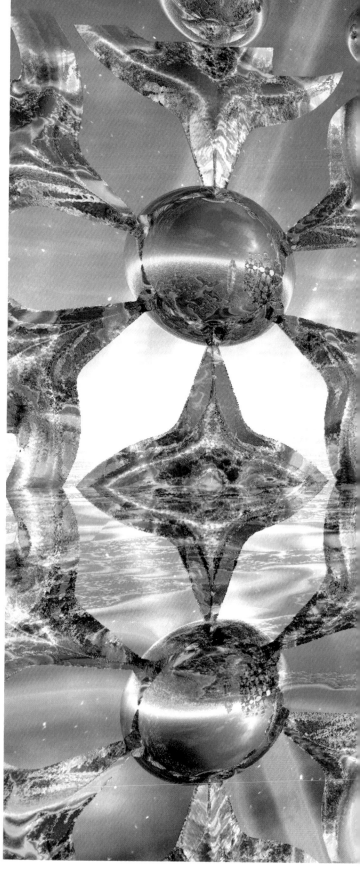

▲ Thought Form IX
1995
Private work
Programs: KPT Fractal Explorer,
KPT Bryce

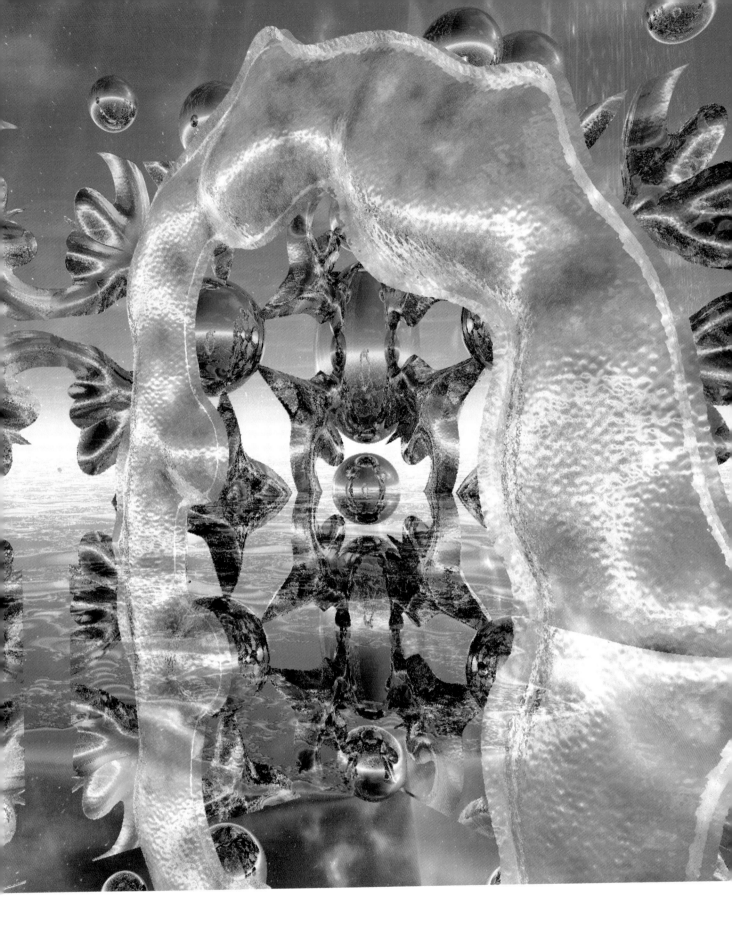

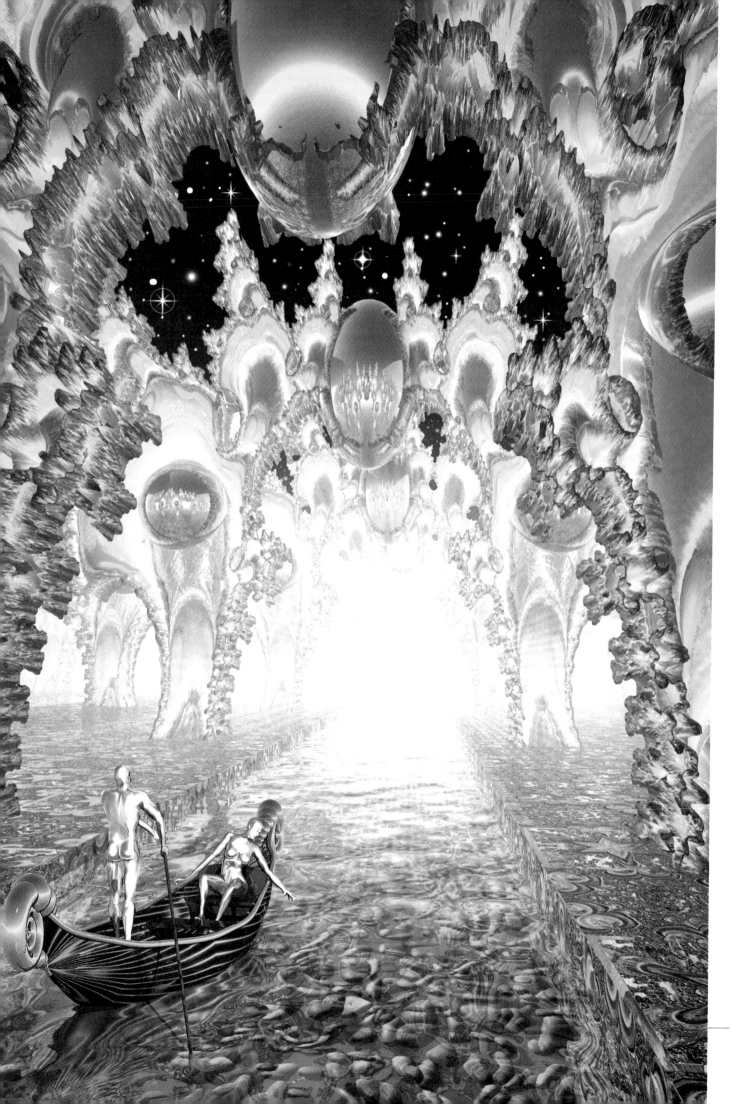

GLOSSARY

3D landscape model
3D model created via conversion of black and white PICT files into terrain where light areas of the image determine high parts of the terrain, and darker shades lower areas.

Adobe Illustrator
One of the first resolution independent drawing programs for the Apple Mac. It describes the image via a collection of mathematically generated curves and lines. This allows drawings to be scaled up to any size without sacrificing definition.

Adobe Photoshop
A post-production program for image retouching and manipulation, blending elements imported from other programs and generally finishing pictures off.

airbrush facility
An electronic tool reproducing the effects of the manual airbrush. Can be operated either by a computer mouse or with a stylus on a graphics tablet.

◄ **The Dream Boat** 1995
Private Work
Programs: Fractal Design Poser, KPT Bryce 2, Strata Studio Pro, Sculpt 3D, Photoshop

bump map
A monochrome image applied to the surface of a 3D model to give it texture. Light areas appear raised and darker areas recessed.

camera marque
A facility of the Strata Studio Pro program to select areas for rendering.

chaos mathematics
The study of complex, seemingly random systems whose behaviour is extremely sensitive to minute changes in conditions. Tiny fluctuations at one point can give rise to massive consequences at another – for example, a butterfly's wingbeat on one continent could result in a hurricane on another. For further details, see *Chaos* by James Gleick, Sphere Books 1987.

contour map
Similar to a bump map but used to build whole 3D models rather than just for adding texture to a surface.

copy/paste
Facility for transferring pictures, or elements of pictures, from one computer file or program to another

DAT
Digital Audio Tape: medium usually used for backing up data.

DXF
Drawing Exchange File: a format designed for transferring 3D images between programs. Developed by Auto Desk for transferring drawings between Auto CAD and other programs, it has become an unofficial standard for this process.

extension
Added facility for either programs or computers.

filter
Module designed to plug into programs like Photoshop to extend their capabilities.

Flo
Program for distorting or 'melting' images.

focal length
As in standard photography, this determines the amount of perspective in the computer's view of a scene, ranging from telephoto effect to fisheye.

fractal
Short for 'fractional dimension', a mathematical way of generating complex patterns by large scale reiteration of simple steps.

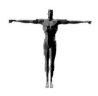

Fractal Design Poser
Program for determining the basic build and pose of computer-generated human figures.

Gigabyte (GB)
1024 megabytes or the equivalent of over one thousand million text characters of information.

graphic line model
See *wireframe model*.

graphics tablet
Pressure-sensitive electronic drawing-board on which you draw with a stylus that can be set to replicate the operation of almost any traditional drawing or painting tool from airbrush to pencil.

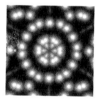

grayscale map
A monochrome pattern used for building 3D models or textures.

hard disk
Storage space inside the computer for programs, data and temporary working information of the running program.

import
Introduce data from one program or file into another.

Julia Set
Invented by French mathematician Gaston Julia in World War I, seen by many as the foundation of the mathematics of chaos and the germ of the famous Mandelbrot Set

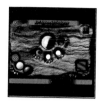

Kai's Power Tools
A series of image manipulation tools that plug into Photoshop.

kaleidoscoping
Taking an element of a scene and mirroring it against itself several times.

KPT Bryce
User-friendly landscape creation program.

KPT Fractal Explorer
Part of KPT Powertools II Plug-ins which allows you to explore fractals interactively.

KPT Gradient Designer
Part of KPT Powertools which allows gradients of colours to be applied to selected image areas.

KPT Texture Explorer
Part of KPT Powertools for generating random textures which can be evolved quickly and intuitively by a process of simple selections.

light source
The equivalent of the position of the sun or studio lighting within a 3D computer construct

Magic Wand tool
An automatic selection process which selects image areas by hue. The tolerance level can usually be set to encompass a greater or smaller range of the hues of one colour.

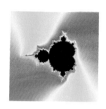

Mandelbrot Set
The defining image of chaos mathematics, an icon of infinite complexity and beauty derived from simply repeating the formula $z = z^2 + c$, where c is a complex number, and plotting the results.

Mandelzot 2.0
Program for generating fractal patterns.

mapping
A picture file applied to the surface of a 3D model to give it its final appearance and add realism.

Megabyte (MB)
A standard unit for measuring the information storage capacity of disks and memory. 1,048,576 bytes of information.

Morph program
Program for merging different

images, e.g. human and animal faces. It identifies shared features of the two via point and line then plots the average as a new picture, creating a hybrid of the original images.

Multiprocessor
Computer which divides the processing tasks between two or more main processors.

optical disc
Compact disc which stores picture information in digital format. Many high street film processors are able to copy normal photographs on to CD, which can be directly accessed by the computer without having to resort to scanning the image yourself.

PICT file
A standard Macintosh graphics format for object-oriented graphics. PICT is an abbreviation of picture.

pixel
The smallest monochrome unit of an image.

platform
Computer operating system.

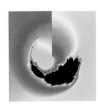

polar co-ordinates filter
Module that allows the manipulation of an image around a focal point.

public domain
Non-copyright software or images (though the small print needs to be checked for commercial applications).

RAM
Random Access Memory: the factor which determines how much information the computer can handle at a time. Basically you can never have too much of it for 3D modelling.

Raydream Designer
A 3D modelling program.

raytrace rendering
Highest level of rendering which calculates and introduces light reflections, refractions and shadows by bouncing a virtual ray of light off the objects in the computer model.

realtime
Computer processing so fast that it synchronises with the actions of the operator without delay.

rendering
Building a detailed 2D image from the 3D model in the computer.

resolution (of image)
The degree of detail of an image measured in dots per inch (dpi).

RISC
Reduced Instruction Set Chip: the main processor at the heart of the Power Macintosh which determines the speed (measured in MHz) at which it can work.

scanner
Device for translating physical pictures into digital information that can be stored and manipulated within computers.

Sculpt 3D
3D modelling program which was originally designed as a 3D CAT program mainly used by architects, but has now been adapted to the Apple Mac OS.

Silicon Graphics
Unix based workstation used as a high end graphics computer, often used as a processing engine for computer graphics in the film industry.

smoothing angle
DXF Files usually convey an angular 3D image because it is stored as a triangular mesh. The smoothing angle determines the degree to which the facets are removed.

Spheroid Designer
Metatools plug-in module which forms part of Powertools 3 filter set. It allows the design of spheres and clusters of spheres.

Strata Studio Pro
3D modelling and rendering program.

Swivel 3D
Early modelling program, now discontinued.

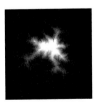

terrain map
Black-and-white image file which

determines the contours of a terrain according to the lightness of tone.

terrain modeller
The facility that converts a terrain map into a 3D model.

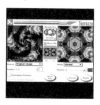

terrazzo
Plug-in filter for Photoshop creating geometric tile patterns from selected elements of a picture, according to a variety of possible combinations of the element.

texture
Any picture which can be applied to a computer model to give it the required surface appearance.

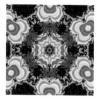

texture mapping
Applying three-dimensional detail to a surface without altering the object's geometry, also reflectivity and transparency.

tolerance
See *Magic Wand tool.*

Virtual Reality
A 3D computer-generated environment.

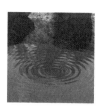

wave filter
Plug-in filter for Photoshop that allows ripple effects to be added to water in a picture.

window
Part of screen which contains either the image being worked on, tool options or your operating area.

wireframe model
Hollow outline of 3D model defined by a mesh of closely spaced lines.

Acknowledgements

Martin Powderly, Ben Wilson, Martin Carter, Trevor Jones, Nigel Suckling, Paul Skellett; Helen Williams, Michael Burgess, John Strange and Pippa Rubinstein at Dragon's World; Robert and Melinda Tenty, Mike Regan, Nick Vince, the programmers who developed KPT Bryce; Aden, John, Warren and Simon at Solutions Applecentre, my wife Julia, and children Martina (for posing as a fairy) and Naomi.